Imperfect Mirrors

Imperfect Mirrors

Kevin Scully

Shoving Leopard

First published in 2011 by

Shoving Leopard
Flat 2F3, 8 Edina Street
Edinburgh
EH7 5PN
United Kingdom
http://www.shovingleopard.com/

Cover: Nial Smith Design, 13/4 Annandale Street, Edinburgh, EH7 4AW
Cover photograph: Michael Marten; http://tpdv.marten.org.uk/
Editor: Simon Barrow; http:www.ekklesia.co.uk

ISBN: 978-1-905565-19-1

A catalogue record for this book is available from the British Library.

Acknowledgements

I must admit that I am one of those readers who tends to skim over acknowledgements. Who are these people? They might be important to the author but what do they matter to me? Having said that, it would be impertinent and improper not to acknowledge the support that has resulted in this book.

First and foremost must go thanks to fellow practitioners on the stage and in the Church – those named in what follows and those whose names are in my heart -- who encouraged me to undertake this experiment. Thanks is also due to those whose efforts led to the period of study leave during which I removed myself from parish life to concentrate my energies and thoughts, especially to those who, at the time, were in positions to make it happen. To that end, thanks go to the Rt Rev Stephen Oliver, Bishop of Stepney now retired, and the anything but retiring Fr Andy Windross, his wallah for all things ministerial. Grateful acknowledgement is made to the Diocese of London and to the Ecclesiastical Insurance Group, whose Ministry Bursary funded some of the work, and the Grants Committee of Sion College.

I am indebted to a number of people in Sydney where the rubber of the ideas hit the road of action. Essential to this work was Brett Wood, a director and acting teacher at the Actors Centre, where the physical work took place. Likewise to the founder of the Centre, Dean Carey. Thanks to all at NIDA at the time of the project, especially the then librarian Chris Roberts and her library staff, who made me welcome and made real a link between my rehearsals and my alma mater. Terence Clarke gave some valuable insights, not the least in the Actor as Priest element. Others who gave guidance or challenge are mentioned in the text along the way.

I would also like to record my indebtedness: to my family in Australia, especially my mother Norma, who has since died, with whom I shared many a cryptic crossword puzzle to clear the grey matter; friends who provided me with meals, wine and a grounded reality while I was at far remove from "normality"; to my wife, Adey Grummet, for struggling to survive the tyranny of distance. Such people ensure any artistic or spiritual endeavour does not evaporate into delusional delight or despair.

Thanks also to my colleagues at the time, the Rev Rachma Bush and the Rev Sr Helen Loder who, with the saints of St Matthew's, Bethnal Green, continued the sacred performances faith requires in my absence.

Lastly, my thanks to Hugh Dennis for the Foreword. Like most key castings his was the last, and only after he read the script.

Kevin Scully
June 2011

Contents

Acknowledgements		v
Foreword		ix
Chapter One	Rehearsing The Liturgy	1
Chapter Two	The Directors' Cut	4
Chapter Three	Meetings With Remarkable Men	12
Chapter Four	Leaving The Comfort Zone	18
Chapter Five	Words, Words, Words	27
Chapter Six	Word And Deeds *part one*	33
Chapter Seven	Word And Deeds *part two*	39
	Afterthoughts	45
Chapter Eight	Priest and Actor	46
Chapter Nine	The Holy Space	54
Chapter Ten	Pathways to Performance	61
Chapter Eleven	When Speaking In Church!	65
Chapter twelve	Lifting Holy Hands	71
Chapter Thirteen	Developing The Third Eye – Outside Looking In	78
Chapter Fourteen	Developing The Third Eye – Inside Looking Out	88
Chapter Fifteen	Zen, Kabuki And The Mass	96
References And Credits		105

Foreword

In interviews I am often asked whether I ever considered becoming a priest. It is, I suppose, a fair enough question, for I am a child of the vicarage, or more accurately various vicarages and a couple of Bishop's houses. First there was the Isle of Dogs where my father was team vicar, then Edgware at the end of the Northern Line, Ripon in Yorkshire, where my father served as suffragan, and finally Suffolk when my father was made Bishop of St Edmundsbury and Ipswich.

As if that wasn't a clerical enough up–bringing, my father's two sisters also both married vicars, so my cousins were clergy children too, while my Godparents were the daughter of a Rector, and a Bush–father. I grew up steeped in clergy life and clergy language; like my friends whose parents were doctors and therefore knew the meaning of the word cardiologist way ahead of the rest of us, I cannot remember a time when I didn't know the meaning of the words ecumenical, liturgy, transept, or sacristy.

And yet I never did consider the priesthood. Which isn't to say that I was uninfluenced by my childhood just that its effect led me in a different direction.

In fact I am certain that had I not been brought up in a vicarage I would not now be an actor/comedian. There, proof of the influence already, for, like the Church of England, I cannot quite make my mind up what I am.

Church for me was a place of performance. I have never worried about standing up in front of people and speaking to them, because that is what I saw my own father do every week. Admittedly he wasn't playing it for laughs, but the parallel is clear. I have never worried about writing material and performing it, because every Saturday at around tea time my father would take a deep warm bath in which he would prepare his sermon for the next day — a sermon incidentally always performed without notes, presumably because whatever notes there were would have been un–readably soggy.

Likewise wearing different costumes never seemed alien to me, given the array of splendid outfits hanging in my own father's wardrobe, and which — yes, I will admit — I did secretly try on when my parents were out.

To me there would seem to be a direct correlation between growing up as a clergy child and my ultimate choice of career, which is perhaps why I meet so many others of my ilk who have followed the same path. It seems that theatrical sons and daughters of the clergy can often owe a debt of gratitude to the performance they witnessed from the pews.

It is intriguing, therefore, to see whether the reverse is also true. Can the clergy learn from the acting profession? What can be added to the liturgy by the disciplines of dramatic performance? And that is why I am delighted to be able to provide the foreword to this book in which Kevin Scully, actor turned priest, tries to answer exactly those questions....

Rev Kev, this is your five minute call. On stage in five minutes please...

Hugh Dennis

Chapter One

Rehearsing The Liturgy

Genesis

It was a simple idea. But, like many ideas that have a comparatively uncomplicated genesis, the simplicity did not last. That was because instead of being a seed for a linear development, the idea was more a pod that exploded only to disperse its contents in many different directions and be germinated in several locales. Those who have been involved in watching it burst forth, migrate and grow have had to engage in a series of activities which rightly should lead to a range of diverse gardening metaphors: watering, weeding, pruning, even slashing and burning.

What was the idea? To remove oneself from the normal round of the priestly and pastoral to work on aspects of performance of some of the tasks involved in that circuit. To take a step back from the churchy networks and go to a place where a metaphorical follow spot would be shone on the work of the priest as actor. In doing this, it was also an attempt to break the traditional way of learning in the church: that of reading a book while sitting on one's bum.

By going into the rehearsal room, to do so in the context of an acting school, and to allow what happens when you are on your feet, one changes the entire method of approaching liturgy. The theoretical, the academic, is put to the test. In the same way a play text is enfleshed by performers, the liturgy should take on the life of its gathered humanity. And, in the same way that actors and spectators have necessarily different tasks, priest and congregation act out their respective parts.

That is what the idea was: to refocus on the priestly aspects of liturgy, and work out or work on what helped or hindered, what could be improved, cast aside or left alone, in the service of others engaged in the play called a church service.

Reading and study would accompany this. It is essential that it does. In this case, however, it was a secondary activity. Action was to be primary. Reflection would assist and follow. It was a journey, if not without maps, that flew in the face of traditional

theological and liturgical training. For that reason, it was in some ways dangerous.

There is an inevitable "I" in this. The author, Kevin Scully, I, was an actor. I had trained at the National Institute for Dramatic Art in the 1980s, worked as a professional actor in Australia, supplementing my income as a writer and journalist, before moving to Europe where, on a tour in my first lead role, Jimmy Porter in *Look Back in Anger*, I came to the realisation that I needed to scratch some sort of existential itch. Itches should not be scratched. Such intervention only augments the presenting condition. I scratched. And I soon found myself on the path to testing a vocation to the Anglican priesthood. (For those who might be want to learn more of this entertaining odyssey, I resort to a bookish recommendation: Adey Grummet, *Suddenly He Thinks He's A Sunbeam*, Triangle Books, London, 2000.)

Twelve years after ordination, having done a diploma to degree conversion programme on the *Actor as Priest* through NIDA, I was poised to carry out the complementary work, *The Priest as Actor*. That was my idea. And that is what led to the work in and out of the rehearsal room that forms an important part this book. As I have said, the idea was simple. This volume will seek to take the reader on the journey from idea, through complication and consultation, through the testing rigours of rehearsal, to reflection.

To that end the book will seek to address a number of issues and techniques. It will be both prosaic and, at times, unavoidably self-centred. This latter quality, if not a flaw, will be represented at times by the equivalent of a rehearsal diary. Rehearsals should allow exploration of text but should not be confined by or to text. Such exploration should lead to enquiry. Actors tend to concentrate this exploring, in some part, on themselves. This has been wonderfully captured and sent up mercilessly, not the least by actors themselves. I do have a morbid wonder if this might be held up as the clerical equivalent of *I, An Actor* by "Nicholas Craig." [1]

Yet actors, for all their satirical pomposity, only make sense in front of, and be made to make sense by, an audience. Likewise, the role of a priest in liturgy is, of course, not remote from the people who have also gathered to take part in what has been defined classically as "the work of the people". Yet one can only

assume, or hope for, audience reaction in a rehearsal room. The absence of immediate response leads to a series of queries: is this line really funny? Will this gesture by this actor add to or distract from the actions of the play? The interim judge is the director, whose task involves guiding and assessing the work of rehearsing performers. And the ultimate judge, despite what the critics might think, is the audience.

It is virtually impossible to include the input of others when one works alone. This is true in the theatre but it is even more so in church. That is because liturgy is not a performance with an audience. Or, at least, I hold that it should not be. It should be a communal gathering where passivity is transformed into engagement. Or maybe that is what liturgists like to think.

Already the idea is becoming complicated. And already there is a need to step back and follow the journey on its development. This book is an attempt to do just that — to engage with the development of the idea. And it is hoped that its individual path might lead to a greater communal engagement of what the Church claims to be its essential act, that of remembering the actor and author of all in the play of himself – God in Jesus Christ.

So I invite you to join me on the journey in which I hope to, as Hamlet advised the Player King, "suit the action to the word, the word to the action; with this special observance, that you o'erstep not the modesty of nature." (Act Three, Scene 2). How successful that is, I have already conceded, cannot be mine to assess.

Now…

Chapter Two

The Directors' Cut

An idea that is not developed is just that – an undeveloped idea. There is no shortage of clichés on how to offer advice in this area:

- for writers: "The longest journey is from the lounge chair to the typewriter"
- for church councils: "You know what you should do is...." (then the speaker can supply the latest half–baked idea)
- for a theatre company board: "We need something that is innovative that will also be attractive to our traditional audience"
- for disaffected local residents: "Somebody should do something about this" (while doing nothing about this themselves)
- for bishops and directors: "I have been thinking and I have an idea"

It is easy to parody. It is easy to laugh at. And it is even easier to get caught up in. The real difference between the waffler and the doer is the preparedness to move from good idea to implementation. The challenge for me was to turn the idea to action; to move from the abstract to the concrete.

There is almost always, however, a hitch. That is sensible. There is a need to put ideas under the intellectual microscope. They need to be tested, if only theoretically. Everyone I had spoken to seemed to think the idea was exciting, interesting and engaging. What I needed to do know was if there might be some substance to those opinions. Was what was being said were really true? More importantly, was it doable? It needed someone at a remove. It required the equivalent of the mythical school governor, a "critical friend".

I was lucky enough to have one readily to hand. She is my wife, the singer Adey Grummet. She was the first link in a chain of connections through to Tom Morris, then Associate Director at the Royal National Theatre. Adey had worked with Tom on a number of projects, perhaps most notoriously in the development of *Jerry Springer the Opera* by Richard Thomas and Stewart Lee, when Tom was Artistic Director of the Battersea Arts Centre. The BAC was known as something of a powerhouse of ideas, development and

new work under his leadership. This ethos seems to move with him.

Morris has since moved on to be the Artistic Director of the Bristol Old Vic where his policy of experimentation continues. Tom and his business associate, Emma Stenning, head up a defined approach at the theatre. To quote the theatre's website:

> *Our development trajectory will carry inherent risk. The intention is to work with the risk not against it, to build on the shared passion of audience and artist, to respect and include both while always pushing innovation and surprise. Bristol Old Vic seeks to be an open institution and we welcome your feedback. Please join in through our email list, our blog and our public meetings.*

I did not quite understand the implications of that statement when I read it. I came to when I sent Tom a play entitled *The Poetry of Silence*. Simon Godwin, to whom the play was passed, put flesh on the bones of this for me when, in his rejection of the play, he wrote, "... we are placing a real emphasis under Tom's regime on innovation and I feel the play – although ingenious – doesn't push the boundaries enough of what a play might be." This, however, was in the future and about another project.

As I said, at the time of my overture to Tom, he was to be found between the BAC and the Bristol Old Vic, at the National Theatre. I emailed him and asked if he might be interested to discuss my proposal. He did. And, grown up, creative and resourceful man that he is, he suggested that we have lunch. The former journalist, actor and inner all–round freeloader in me said there was only one response to this suggestion, even if I did not know who was destined to pick up the bill. It had to be "Yes".

It was a brilliant sunny day. We met at the stage door of the theatre and strolled down the South Bank to the newly-established range of eateries on the sunny side of the Thames. Tom, his traditional three–shirted sartorial self, and I picked our fare and settled down to a mixture of an Oxbridge tutorial and gossip session over food. Tom Morris was clearly the tutor. He listened to my proposals and we spoke of literature for and about liturgy and the theatre.

My notes in the diary of that week record the suggestions of recommended reading that the tutor had for me: *The Monk* by

Matthew Lewis and the records of the Bread and Puppet Theatre by Stefan Brecht. I noted the suggestions and, short of having to churn out an essay before we next sat down together, knew that it was up to me to make of it what I could.

As we ate we spoke of the idea and its implications for the theatre and for the church. There was a focal point on the need for audience/congregation to be engaged/involved with the play/liturgy. Tom saw an obvious parallel, rooted in a literary reference – "designs on the audience" – which he thought came from Keats.

My research into this concept later found it to be Keats writing in February 1818 to his friend, a clergyman as it happened, The Rev John Hamilton Reynolds. It comes in the poet's consideration of the notion of negative capability, something which revelled in human uncertainty. This moved, it was hoped, to a place of open mindedness. Keats had written to Reynolds:

> *We hate poetry that has a palpable design upon us – and if we do not agree, seems to put its hand in its breeches pocket. Poetry should be great & unobtrusive, a thing which enters into one's soul, and does not startle it or amaze it with itself but with its subject. – How beautiful are the retired flowers! How would they lose their beauty were they to throng into the highway crying out, "admire me I am a violet! Dote upon me I am a primrose!"*

Back at lunch, Tom Morris and I spoke of the essential dichotomy of engagement and alienation that performance necessitated. His questions that flowed from the recollected Keatsian quote were these:

- does the priest explore uncertainty?
- is there a theatre of doubt?
- what sort of crossover is there between church and theatre?
- do we supply answers, or a template for entering the shadows of the undefined?

How such elevated themes could be explored through my reading of a gothic novel which pointed out the faults and failures of people of faith — a raping monk whose speciality lay in deflowering virgins with demonic assistance — was a puzzle. But then, I was cast in the role of the student. And the tutor, I thought I realised later, had simply replicated a reading suggestion of his

equivalent to any undergraduate wanting to come to terms with the *Grand Guignol* in English Literature.

Weighty matters

The Brecht was something else. It is the sort of "Look at my poo" book that is hard to imagine would find its way into print today. Indeed, Tom led me to the National Theatre's bookshop where he searched for, found and purchased this curiosity. It had, according to the perennially helpful staff of the shop, been sitting on the shelves for a couple of years. I assumed it was unlikely to be restocked on sale. It was probably well out of print. The dog-eared, well-thumbed and fat volume remained unsold. Until now. Tom purchased it and presented it to me.

It is not just me that suggests there is something scary about this book. Try this, and it is just from the title page: Stefan Brecht, *The original theatre of the City of New York from the mid-sixties to the mid-seventies. Book 4. Peter Schumann's Bread and Puppet Theatre, Volume 2.* The bookshop staff, perhaps in delight that so much space had finally become usable – the book is almost two inches across the spine – did not know if Volume 1 was available. They played a bit with a computer keyboard, scanned the screen, shook their heads in a manner similar to a plumber looking at a blocked drain, and aired the opinion that it would be "hard to find." An Internet search that did not enter into the darkest realms of e-dom informs me that the bookmongers know their stuff. (I later tracked it down at the Ronald Seaborn Library at NIDA in Sydney. It was as large, detailed and dense as its successor and drew a similar response from me as to the Volume 2.) Though, in a mystery I have not unravelled, the second volume is comparatively easy to get hold of.

Brecht's book is detailed to the nth degree. Brecht is an assiduous chronicler of events, people and opinions. The Germanic style is at times baffling. A member of the company will be quoted in the text. A full reproduction of the source document, often in untranslated German or French, will be given in a footnote. This can be daunting. Some pages have less than a quarter of surface area given over to the text proper, such is the lavishness of the smaller writing under the line. The footnotes on occasion go over the page.

It is documentary material, by and large, though no issue seems unworthy of attention. Tension among members of the company, the vision of Schumann, the themes, texts and presentation style of his work — all are covered. And it does give a wonderful insight into the chaos of political creativity mixed with a personal and spiritual journey.

Why had Tom recommended this? The Bread and Puppet Theatre used many different styles of enacting their designs on the audience: formal spaces, street events, promenade theatre, mixtures of elements of each. And there were explicit and implicit religious themes: Stations of the Cross, the Journey of the Magi, Mary. And there was a period when the theatre appeared to mount nothing but religious presentations. This was a major source for the potential of my work: where performance met religious themes in a context that altered the relationship between audience and performer.

Tom Morris and his collaborator, Carl Heap, had explored this in their own way. The three big Christmas and New Year shows in the main space of the Battersea Arts Centre, where Tom had been Artistic Director, were already the stuff of legend. Well known stories were re-interpreted, often with an opening that Bertolt Brecht would have acclaimed as the alienation captured his V-effect[2]: the staff of a Victorian household put on their own presentation of *Ben Hur*, with the audience at one point waving flags in support of the racing charioteers; a village fair transmogrifies into *Jason and The Argonauts*, with members of the audience joining the galley of rowers; and in *World Cup Final,* and Tom made specific reference to this, a pseudo-meal was shared when the audience ate the oranges at half time.

Journeying into e-space

Leaving the South Bank that day I felt enlivened. The idea had shown its appeal once more. And someone could see an intellectual basis for it. There still remained the practical question. Who would be mad enough to work with me in such a way as we could, as directors and actors say, get on our feet? That would be another negotiation across cyberspace.

The first, and seemingly obvious place, was NIDA. It is an institution that welcomed and supported me in the 1980s. I had

auditioned for the college in Sydney at the end of my final year in high school in 1973, only to be told by Aubrey Mellor that there was not much call for Ocker Shakespeareans. (Ocker is a kind of über-Australian working class oik, a satirical creation embodied by the actor Ron Frazer in the 1960s.) Mellor and other members of the panel had just been assaulted by my western suburbs Edmund in *King Lear* – "God stand up for bastards". I was one of three who made it to the end of the day. Aubrey took me into a small office and gently told me that I needed to take a year out to get some life experience. As far as I know no such advice about taking a gap between school and college was considered necessary for another Roman Catholic school educated boy who auditioned the following year — one Mel Gibson.

Six years after that initial encounter Aubrey once again put me through my auditional paces. It was challenging, exacting and appropriate. This time, a result of his incisive direction and my ability to take it — a talent I was to lose temporarily while training — I got in. I was 24. That meant, in the way of acting schools, I would have to fight to play nobody under the age of 60 in my time there. I should have recognised there and then that I was professionally washed up. That, despite the message that should have been even more obvious in the reluctance of major agents to list me on their books on graduation, took another ten years to penetrate my consciousness. But that is another tale of angst and bitterness.

When I first contacted NIDA with the genesis of the idea of this book there was a gushing response from the newly appointed Director. The Director was the same Aubrey Mellor, who had quit teaching at the college during my first year to take up the post of co-Artistic Director of the Nimrod Theatre. By the time of his appointment as the head of NIDA, he had moved to the Playbox Theatre Company in Melbourne. He had been selected to replace the founder of institute, John Clark. I emailed Aubrey my seminal idea. The response was encouraging. It was only when my protagonist realised I was serious that this became problematic. It would need space, time, staff, commitment and funding.

Initially it seemed the prospect of working with a cleric in a theatrical setting was exotic and exciting. Aubrey reminisced about some churchy matters and considered the possibility of

using the Book of Common Prayer for vocal production. The heat seemed to drop out of the matter for him and his responses became relatively evasive and discouraging. However, on his suggestion, I started an exchange of further exploratory emails with Terence Clarke, director and composer, as well as Co-ordinator of the (degree) Conversion Programme.

Terry had, among many other things, directed a play of mine, *Urgent Copy*, at the 1986 Australian National Playwrights' Conference. Terry's reaction was positive. He could see the project being of potential worth to both persons and institution. We decided to continue exploring the possibilities of bringing the idea to fruition. This process was to culminate with a face-to-face meeting when I was in Australia in August 2005. That meeting had to be cancelled because the sudden decline of health of my father Ken, who died surrounded by his family. Not surprisingly, more immediate personal and familial concerns captured my energies. The missed meeting was never adequately replaced.

After that things went cool. I should not have been surprised. My time in the theatre as an actor, playwright, director and author should have reminded me that the difference between a good idea and a viable one was a complex amalgam of friendship, influence and career projection. A lot depended on personal contact. I had fully expected a professional response with a fee and a programme. My cynical interpretation to what I got was a movement from the initial "How wonderful, why can't we do this for every ordained person who speaks in public?" to what later transpired to as: "What? You mean you were sober and you really want to do this?"

Emails and phone calls in several directions ensued. I was worried that the idea would remain just that – an idea. I was seemingly unsuccessful in attempts to broker a way forward. The missed interview meant negotiations could only be resumed at arms' length. The church was enthusiastic. Funding looked set to follow goodwill. Only the receiving institution seemed timorous.

Another theatre training organisation exists in Sydney. It was established by Dean Carey, who has wide experience in teaching acting. Dean and I started in the same class at NIDA in the 1980s. He had many diverting skills. These were often displayed in front of the terror-inducing octogenarian tutor, Margaret Barr, whose

mis–titled sessions on Improvisation led to corporate diarrhoea among first year students every Wednesday. Among Dean's singular contributions was a mimed juggling of pancakes for the sense of touch. His portrayal of fear was likewise memorable. He lay inert for some time on the floor of the hut housing our studio. Eventually he looked up, gazed quizzically at Miss Barr, hesitantly approached her, looked deeply into her face, then screamed and jumped out of the window. Our other key experience was in our second year when we performed *The Zoo Story* by Edward Albee under the direction of the student director Gale Edwards. I, as Peter, sat on the bench that Dean's character of Gerry approached, distracted me from the book I was reading and, after telling what is the greatest shaggy dog story in theatre, eventually impaled himself on the knife he had got me to hold.

I pitched my idea to Dean by email. In the time–honoured tradition of directors, he passed me to a colleague, Brett Wood. It turned out that Brett had some contact with the church. His brother, Michael, was an Anglican priest in Western Australia and he had offered some workshops for clergy in that state. He was interested in my project. Small confusion followed but swift negotiations replaced it. We brokered a number of sessions that would take place after I had arrived in Sydney. His name will feature prominently in the chapters that spring from a rehearsal diary.

Cyberspace interchanges, organisations and applications were far from my mind as I strolled across Hungerford Bridge after my lunch with Tom Morris. The sun was shining. I had had a couple of glasses of good white wine. The lunch was delicious. More importantly, it seem the idea had potential. It was beginning to appeal to both constituencies – church and theatre. Who said there was no such thing as a freeing lunch?

Chapter Three

Meetings With Remarkable Men

Every great movement has a centre. It can be a place, a practice or a belief structure. Sometimes it can involve all three. And it can often involve travel. Jerusalem is essential to all three Abrahamic faiths. And each of them, Judaism, Christianity and Islam, have writings at their core. Armed with the writings and the spiritual heritage, many people make pilgrimage to the holy city in the Holy Land. Jews pray at the remnant wall of the Temple, just under the site of the Dome of the Rock, not far from Holy Sepulchre.

But Jerusalem is not alone in being a place to which the faithful flock. The Sikh gravitates towards Amritsar. The Hindu is drawn to the Ganges. The Roman Catholic heads for Rome. The Muslim makes the hajj to Mecca. The Buddhist wants to go to Dharmasala.

Neither is religion essential to this sense of magnetic attraction. Political history can be a powerful lure. Americans have an embodied reverence to Washington D.C. They come from all over the United States to visit the national shrines located there. They will go to the public buildings of the nation: the seat of government; the presidential residence; the memorials and graves of famous fathers, from Jefferson, Lincoln to Kennedy. They will visit museums where they queue to see Old Glory and the dresses of first ladies. They will scan the list of names for relatives among the war dead.

This is not a peculiarly national trait. It happens when people travel both within and across borders. One just has to witness the behaviour of the thronging crowds in London around Westminster, with snaps being taken in front of the tower of Big Ben, Bobbies and Buckingham palace. Similar scenes are to be seen at the Forbidden City in Beijing or the entombed warriors at Xian. Again, they can be viewed in St Mark's Square in Venice as tourists make their frustrated or successful attempts to photograph countless works of art in that sinking, floating city. Countries and cultures each have their talismanic draw cards: the Eiffel Tower, the Sphinx and pyramids, the harbour bridge or opera house in Sydney, the Taj Mahal, Brandenburg Gate to name but a few. In each case, it attests to some deep draw on the individual, collective or promoted heart.

Sports fans undertake similar expeditions. Football fans make pilgrimages to home grounds when abroad, even if it is out of season. I was once bewildered on a coach ride by a man who revealed the contents of a folder full of photographs of empty stadia, reeling off the seating capacity and names of nearby pubs. This, he said with pride that contained no hint of sadness, was what he did on his holidays. A friend of mine, on arriving in the capital of South Australia made straight for the (closed) gates of the Adelaide Oval, as he had seen them so often in broadcasts of test cricket. To be amusingly fair my friend, a priest, also wanted to visit Adelaide Cathedral for much the same reason. He did, of course, insist on his photograph being taken in front of both shrines.

Seekers of something lost go to houses and graveyards, or even places in libraries. I had myself been involved in a holy farce. One of the lost joys in relocating the national book collection of the British Library from what was the Reading Room of the British Museum is the daily competition to stake one's claim to park one's bum at the desk that was reputedly used by Karl Marx for his researches for his singularly engaging and arguably unreadable *Das Kapital*.

This *recherché du temps perdu* can be enshrined in other ways. The home of a great writer will be marked with a memorial plaque. Charles Dickens, T. E. Lawrence, Lytton Strachey, Henry James, Jerome K. Jerome, James Joyce, Dylan Thomas are just some of the diverse motley to whom memorials have been plastered in the metropolis that is London. Some of their residences are given over to museums stocked with verified utensils of the great one or, more shamefully, a faithful recreation of objects from the period. One could choose music. There is the wonder that Jimi Hendrix and Friederich Handel were almost next–door neighbours, albeit separated by almost two centuries. Elgar, Mendelssohn and Sullivan each have their enthusiasts. The same can be said for the exponents of many other skills and pastimes.

And the pilgrim often feels the need to record their presence, either by capturing the image, as repeatedly happens as traffic is brought to a halt by people on that pedestrian crossing near the Abbey Road studios in London, or by graffiti and other atrocities, such as those near the grave of Jim Morrison in the Pére Lachaise

Cemetery in Paris, or the less marring offering of flowers, cards and mementoes.

Reality need not figure in this. Nostalgia or enthusiasm can be motivating triggers. Thousands turn out to events which celebrate the creative and the questionable. Trekkies dress up in approximations of what were television costumes and speak an invented language into the shell of each other's plastic ears. People will don period costumes to follow the journey of one day's life of a fictional Dublin Jew. Tours can be taken to sing "The hills are alive!" atop a hill near Salzburg, and then to take in all the other backdrops of that sentimental celluloid blockbuster. Pilgrims make journeys to the West Country church where the likewise fictional Lorna Doone met her end or, more bizarrely, to Verona to see the balcony on which Shakespeare's Juliet stood to listen to her Romeo.

Such journeys can be personalised. As a priest in inner London I am often contacted by those wanting to see where their progenitors came from. Their appetite for this undertaking often becomes ashen disappointment when they come to the realisation that they may not be the only person to have made a similar journey. Or they may become downcast when they encounter the reality of inner city London. They want to sit in the church their ancestor was baptised or married in. The walls in Bethnal Green remain the same, but the interior, like the stones of the graves, often to the disappointment of the traveller, are no longer that of historical memory. The place bears no indication to the events that stimulate them. The church has had five interiors in its 260–year history but this does not deter them. It is the intangible sense of rootedness to place, even if it is lost in time, that attracts them.

People also travel to places to explore the backdrop of events in their own existence. A few years ago I retraced the steps of earlier parts of my life by going to Australia where I visited my old schools, walking to the street where I grew up, standing staring in disbelief at the family home, visiting the churches we attended and the grounds on which I played various codes of football. Of course, nearly all of it was recognisable. But much of it had changed. The familiar shop fronts, goods, even ethnicities had gone to be replaced by a newer, slightly exotic present.

There was for me a certain similarity of journey in launching into the performance of church ritual. Returning to my native city,

having negotiated with the authorities of the college in which I trained as an actor, there was inevitably a sense of going back. When I was a would-be thespian, easing out of my work as a broadcast journalist, with its especial unsociability of rising early to start work at four in the morning, I would soak up all things theatrical. It provided sanity in the madness of journalistic reality.

The man of the book

One of the first books to lure me was on the shelves of a house I shared in a harbour-side Sydney suburb. It was *Experimental Theatre: From Stanislavsky to Peter Brook* by James Roose-Evans. Aspiring to theatre, already pushing back the considerable limitations of my voice, body and intelligence, the book provided a doorway to the imaginative engagement of work on stage. It pointed from the rough and ready to the groundbreakingly tough. The Living Theatre and Jerzy Grotowski seemed, for what now is an incomprehensible train of thought, the extension of the excitement I felt when, in the early seventies when Australia, under the inspired tutelage of Gough Whitlam, exploded in its own art: literature, drama and films.

Years later I discovered that James Roose-Evans was indeed a Church of England priest. He has written about this in a couple of books, some chapters of which bare a scary resemblance to each other. His journey, like that he charts in the book on experimental theatre, did not take the traditional prescribed course. It was one of removal, engagement and surprise. As one version of the book is entitled, it was an *Inner Journey, Outer Journey*.

After my ordination I decided to explore academically some intellectual aspects of my journey. The path I took was one that would lead me to convert my Diploma in Acting to a degree. I chose to do this by looking at the Actor as Priest. I had always a companion piece in my mind, the Priest as Actor. These two aspects have been played out in an unpublished novel, and in an unsuccessful pitch to British publishers on the matter. In many ways, the project of putting myself back into the rehearsal room for direction in church theatrics was more of the same.

When I started out on the research for my degree, I did so knowing I wanted to use some source material from James Roose-Evans. Thinking to capitalise on this, I wrote to him to enquire

if he would act as supervisor to my project. His response was typically theatrical: he was interested but with a concomitant list of prior calls on his time, an expression of reservations, especially in the field of costs. Put simply, he needed some income to support himself. NIDA did not run to such expense. Terry Clarke was in no way second best as supervisor. His direction, both on stage and in academic terms, has been inspiring and fruitful. As a result of this collaboration, I had been hopeful that we might work together on the next project. I wanted to leave bum and book learning of the Church of England, and place myself in a rehearsal room, to allow the engagement with a director, preferably with no religious baggage, to push the limits of my liturgical understanding.

As part of the preliminaries, in much the same way as I met with Tom Morris of the National Theatre, I thought a meeting with James Roose-Evans might prove interesting. It was a hunch worth following. My overture was a phone call. James answered the phone and a charming interchange followed. I spoke of our correspondence years back. He was vague and would chip in some wonderful commands: "Do go on," "Keep talking." Or he would revert to the more casual, "I am listening." Once having heard my proposal and the suggestion we meet to discuss my work, he said, "You will come for tea." A date and time were arranged.

The seemingly grandiose continued as I walked down what seemed to me a palatial street in north London. At the end of it was a building from which sprouted a plate glass window the depth of one storey. I did not realise that it would be through this window I would take in the view. I knocked on the door and was commanded to go to the top of the stairs. The ubiquitous theatrical charting of a career — posters bearing illustrious names in famous productions among them — lined the stairs as I approached the eyrie. Tea was made and the interview began.

It took some time to get to my proposal. James wanted the low-down on my background, my decision to enter and leave the acting profession, my spiritual bedrock and views on certain church controversies. Every now and then there would be an hiatus. His hand would make a gesture of encouragement towards his face. "Go on." "Tell me more." "Keep talking." These were the exhortations.

I had known of his work with the Bleddfa Trust and its interface of creativity and spirituality. I was given its current programme.

We spoke of his production of *Pericles*, which I had seen at the Riverside Studios in Hammersmith. He expressed his opinion that both the play and the production had especial significance to him. It had to me as well. As a student at NIDA I was a member of an exhausted cast pushed to the physical and mental limits by a crazed director who created what was received as one of the most stunning pieces of theatre ever mounted. I was given a photocopy of an article he had written for *The Tablet* on the need for churches to move from the confines of their historical heritage to places of new encounter. This became the theme of much of our discussion. Unbidden, he voiced the opinion that I was wasting my time in parochial ministry and should work to set up a centre of creative liturgy, a kind of research laboratory for making appropriately engaging spiritual encounters.

As to the precise plan of placing myself in a rehearsal room with a director and the issues that a priest, writer and director as experienced as James Roose–Evans might cast some light on, there was little he had to offer. He wished me luck, asked me to let him know how I got on and suggested we should meet and talk again.

Coming so close to one revered from the past does have its dangers. I had brought along a script of one of my plays, ...*As the Bishop said to the Activist*. I had hoped this might be an opportunity to get a leading light in British theatre to cast an eye over my work. He took it, patted the cover and promised to look at it. As is the case with most unsolicited texts, I have not heard a word about it since. Handing it over was perhaps my inappropriate gesture that so often happens in places of pilgrimage.

Chapter Four

Leaving The Comfort Zone

With the long lead-in to the release from bum and book learning, I suppose I should have been more nervous than I was on the day of my first session. After all, it had taken nearly two years to get the structures in place to allow this all to happen. Even then, it went almost to the wire when came to the practicalities. With only a fortnight before leaving London, I still did not know for sure if the projected programme would happen. I eventually secured a proposed series of dates from Brett Wood at the Actors Centre when I was already on study leave in London. My reading rights to the NIDA library were only established two days before I was to enter the rehearsal room.

As I say, there might have been cause for some trepidation in this. My reflections on personal journeys and pilgrimages now had a particular reference. There was a certain nostalgic familiarity in what I was doing. I was trained and used to work in the theatrical environment so there was certain "coming home" quality to it.

There is a certain particular oddity in the location of the Actors Centre in Sydney. It is based within the curtilage of what would have once been a core part of the Irish mission to Australia. Up Devonshire Street from Central railway station, there is a commercial school, St Patrick's, perhaps one of the last of such institutions for the training of young Catholic women for employment in business. Just over the rise from the college is St Peter's Roman Catholic Church.

The church finds itself in the changing inner city suburb of Surry Hills. This was formerly an area of poverty and notoriety. It remains the locus of a large public housing estate. Last century it had the tarnished glean of many areas that edge the commercial district of a growing city. The streets were the backdrop to gangland beatings and killings, especially by the razor gangs of the 1930s and 40s. Here the grand madams of Sydney's underworld, Kate Leigh and Tilly Devine, ruled ruthlessly over their empires of sly groggeries and brothels with the skilful assistance of their gangs.

I had left behind an environment on a similar arc of change. The church I serve is one that, despite its long witness and

achievements since 1746, is best known in London as being the place where some famous hard men, the Kray twins, were commended to God's care and judgment. This was after a life of crime and intimidation in an area that had reputation for being tough and poor. The area, for all the tarnished glamour, is now in a seeming state of perpetual flux with e-businesses, architects' studios and retro clothes shops replacing the furniture factories and rag trade sweatshops.

In London and Sydney much of that criminal background is colourful history. Cappuccino is the daytime tipple of choice among the galleries, eateries and revamped pubs in the two areas of both cities. Art and film companies jostle to keep their offices in the former factories in Sydney. The once derided slum housing is now highly desirable, the high price tag bringing inner city convenience with a nostalgic tinge, if you are interested in what local politicians call the "night time economy" – something that still seems to involve a lot of drink, drugs and sex.

The Actors Centre in Sydney is to be found in the complex of a Roman Catholic parish church. There is a hall and a number of rooms in the church undercroft. These rooms run to a number of studios and a locker room. In the courtyard, where a couple of typically earnest theatre students were running through lines of a scene under a sunscreen canopy, there is also a small shrine to Mary, Help of Christians. On the street side of this structure, to assist the casual or the curious pilgrim, is attached a sign with the information that the she is the Patroness (sic) of Australia. The marble shrine edifice has been executed in a mixture of Irish and Italianate over-the-topness. It houses a rather gaudy statue of the Blessed Virgin Mary, in front of which is an altar draped with a dust cover in her signature virginal blue. In front of both of these is the traditional Sydney don't-even-think-of-trying-to-come-in-here metal grille and gates.

Non-purpose built arts centres have an endearing, haphazard quality to them – such as the old huts and Tote building that housed NIDA until its gleaming reincarnation on The Parade in Kensington – and the Actors Centre is no different. You enter by the narrow gate towards the front doors of the old hall, to be met by a sign telling you not to knock on the doors or attempt to enter, as rehearsals are underway. The sign redirects the visitor to the

office, which is hidden down some stairs off the courtyard with its protective canopy. There is a doglegged entrance way, in which is to be found an urn, a table with the cups, tea and coffee, and then a vast waiting area. Around the walls are notice boards for auditions, jobs to get actors by and thousands of flyers and posters for various productions and the usual attendant businesses to the performing arts: osteopaths, alternative medicine, tarot card readers, confidence coaches and other practitioners of the self-aware and self-to-be-improved.

In the next room is the office fronted by a cheerful receptionist. I asked for Brett, who came forward, shook my hand and asked me to take a seat on one of the old pews, and to get myself a cup of something. I did this and let me eyes graze on the details of the various kinds of literature I had seen on the way in.

There was a factor of irony that I should find myself working with Brett Wood. I had sought to work with a director or directors who had no church baggage. I knew nothing of Brett's ideas and religious affiliations but he had offered the information that his brother Michael was an Anglican priest in Perth. I recalled that he has also told me he had worked with some priests in Western Australia on some of the issues related to those on which I wanted to focus.

After a while Brett came back into the waiting area, and we made our way across the courtyard to the Camera Studio, a high ceilinged room that led off a small narthex housing lockers. There was no camera in sight. The room was in blue – in honour of the BVM? – with black drapes on one wall, windows along the opposite wall, and with a table and some chairs. It was facing this table that we started to work.

Telling stories

There followed some questions to me. Could I go over what I was trying to achieve? How did I think this might help me? What did I think I would be doing? This was linked with what I thought was happening when people gathered for worship. There was also discussion in a cursory way of what tasks the priest performed in the gathered worshipping community. Brett thought trying to come up with a short statement on these matters could assist us in the journey we were about to set out on.

A number of ideas were discussed. There was a short process of distillation to get to the core of the verbiage. The statement we arrived at was this: "To open the door from the immediate into the divine".

This had implications for the self (priest) and the other (congregants). Brett said we would be working at this statement, without being married to it, by using techniques allied to the training of actors, some of which may be familiar to me. Others would not.

He then asked me to tell him two stories. The first was when, at any time, I might have experienced the door opening from the immediate to the divine.

The incident has something of a lead–in. It is the early 1970s. I am in church at Campsie in Sydney's western suburbs for the six o'clock evening mass after a typical Sunday. I get up at six A.M. and go and collect my girlfriend. I go on to Hurlstone Park to pick a mate's girlfriend. Then over to Burwood to pick up a mate, and then to Concord for a second whose girlfriend is in the car. We head off to the northern beaches, Narrabeen, where we surf most of the day. We mix with a crowd of others who go up there. There are blokes, their girls and we pass the time in a mixture of surfing, socialising and romance. At the end of the day I drop people off in the reverse order and, good Catholics that we are, my girlfriend and I go to church at St Mel's up the street from her house. During the Eucharistic prayer there is an unusual focus, a seeming light, a kind of mandala around the priest. It is not the traditional glory that you see around a saint. Just a glow around him, and especially around his hands over the elements, as if he is at one with the words and actions recalling the story of Jesus. They are the same words every week. I know them, so there can be nothing special. And it is a realisation that all the things I have been brought up and taught about this part of our lives, the mass, is true.

The second story he asks for is for a similar event or feeling more recently.

I am saying mass. I have been in the parish for about a year and I am coming to the end of the Eucharistic prayer. As I

am saying the words I realise that my hands have developed a trembling. I am aware that my hands are holding the body of Jesus. I know this from teaching I have received and I deliver to others. And I am not the kind of person who is given to over-emotional engagement at such times. In fact, I tend to abhor it, as I think it gets in the way of doing the job properly. But as I hold up the elements of bread and wine, the body and blood of Christ, I find I cannot put them back down on to the altar. They remain in the air for what seems a very long time. I claim nothing special for this. At the end of the mass two parishioners comment on this, saying that to them it was a very holy moment.

We then discuss the stories and Brett asks me to complete the sentence:
I have an investment in appearing to be…

I supply the word "focussed". I am asked to add another word after "and". This happens again. I end with this sentence:
I have an investment in appearing to be focussed, in control and relaxed.

It is only later that I perceived in this statement something that one of my colleagues in London often accuse me of – that I try to rule my world through my intellect rather than my emotions. I have a tendency to state opinions without the to-me unnecessary lead-in "I think". Of course I think it. That is why I say it. Her contention is that this somehow makes me seem cold, sometimes even ruthless. (I hope this has changed, as there have been a number of changes since in my life since I originally embarked on this project but to explain them would not be germane to this book.)

Words into action

I had been asked to bring a short piece of text, prayer or scripture, to our first session. I had considered, and had sent an email threatening to bring, a much-loved poem which, despite over 30 years exposure, I could still not recite word perfect because the cadences of two lines.

Nor mouth had, no nor mind, expressed,
What heart heard of, ghost guessed.

Spring and Fall by Gerard Manley Hopkins has remained a favourite since being exposed to it at high school. Some would say that it suited a certain bleakness in my personal outlook, captured in the final couplet:

It is the blight man was born for,
It is Margaret you mourn for.

In the end, however, I decided to fall in with the original nature of the request. I had brought two pieces, one in text and the other in memory.

The first was the Collect for Purity, which can be said just after the Greeting at the opening of the mass.

Almighty God,
to whom all hearts are open,
all desires known
from whom no secrets are hidden;
cleanse the thoughts of our hearts
by the inspiration of your Holy Spirit,
that we may perfectly love you,
and worthily magnify your holy name,
through Christ our Lord.
Amen. [3]

The second was a piece from the Bible that I routinely use when I visit someone in the lead up to a funeral. It comes from the third chapter of the letter to the Philippians:

For us, our homeland is in heaven, and from heaven comes the Saviour we are waiting for, the Lord Jesus Christ, and he will transfigure these wretched bodies of ours into copies of his glorious body. He will do that by the same power with which he can subdue the whole universe. [4]

Both had had appeal. I was familiar with them, said them regularly and felt that they were well embedded in my memory.

In the end, I opted for the latter as it is prose and was not directed towards God, as prayers are. Brett got me to say this repeatedly, occasionally interrupting me, asking me what I had just said, which often leads to a new stress on a word. I was requested to speak with my eyes closed, to him, to the wall. Every now and then he would stop me. I could see we were working on making a connection with the text. Already in the back of my head, I could feel the nagging: it doesn't matter what you think about it, what you feel about it. It is scripture and it is for others, so your job, Scully, is simply to get it across clearly. I had a hunch that was what Brett thought as well.

At this point, we get on to our feet – enough on–bum learning for one session and start to do some exercises. What followed was a series of familiar, if long unused, exercises using space, breath and text. The unusual aspect for me was that these had always been done in a group. I was carving journeys through the space of an empty room, verbal cues coming from Brett, with Keith Bain, NIDA's movement teacher, at the back of my mind, telling me break from the easy patterns, to move in and through and around and across. Every now and then I would be stopped and Brett would ask me how I felt. I responded. But the task was more complicated than that. I had to stop and say "How do I feel?" Take a breath in, and then supply in word. This occurred several times. The responses ranged from "good", "relaxed", "fine" to "worried", "nervous", "anxious".

My inner critic thought, "These are not emotions. They are words that avoid them." And herein came a reminder my colleague's observation that while I may feel emotions the thinking aspect of my personality dominated my dealings with others. This, I suppose, is true. But I could feel myself struggling with the work in the rehearsal room and with myself. I was judging it, I was monitoring it, and I was trying to stop myself doing that.

There was another memory. I had read a book, *No Acting Please* by Eric Morris, while I was training as an actor at NIDA in the 1980s. It was a horror of a book. I recall discussing it with Dean Carey when we were fellow students. The opening of the book consists of reportage of what, to my mind, amounted to emotional bullying by the tutor, Eric Morris. A woman in the chair is repeatedly asked how she feels, what she is doing, etc, until she breaks down in tears. This is supposed to be some sort of breakthrough. For me

there is a large dividing line between acting and therapy. I cannot stand it when people try to play across these boundaries.

In the back of my mind, my inner critic is asking me is also asking another question: is this what Brett Wood thinks he is doing? Is he playing with me? Also, there is a niggling memory of another director with the surname Morris — not Tom or Eric — who would pick a whipping boy in each cast. This activity was excused by members of the company until one found oneself in this persecuted role. It nearly did for me when I got cast in it.

These thoughts in the rehearsal room make me realise I am disengaging from the immediate work with Brett. I am called up, told to lift my arms, release my breath and, at various points try to gain his attention by saying, "Hey Brett", drop to release the breath, sometimes to answer once more the query of how I felt, or start the passage again.

At one point he starts to push me physically, lightly slapping my torso and asking if it is okay for him to do this. I reply affirmatively, but the inner critic is gnawing away inside me. This goes on for some time until I am asked to speak the piece of scripture. I do.

Brett smiles. "Good," he says. "I got that." He then goes on to say that it is not a comment he routinely would make. That he understood what I was saying.

We then sit down again and both of us make notes. I feel that I have processed the session on the floor. But I make the notes to myself, noting the difference between reciting material, "acting" it, to being connected to it. The latter has a deeper source. But already the internal debate is underway. Does anyone really care if there is a connection between text and priest? Is not the responsibility of the speaker to make it clear to others? Was I being pushed into the area that I am most critical of? That of personal feeling at the expense of being in situations not for one's own ends, but to be of service to others?

These questions seemed to be taking me from what I thought we would be working on. I had assumed we would take to the floor and rehearse parts of the liturgy. I know different directors have various approaches. Some start with games and improvisation while others commence a dogged working through the text. Whatever was happening, I needed to give myself over

to it. After all, I had initiated this journey out of the comfort zone. Part of the process now had to be giving over control. It would be impertinent to judge where it would end, let alone how I would get there.

Chapter Five

Words, Words, Words

The next two sessions with Brett pushed the relationship between performer and text. Body and breath work were used to explore not only the words themselves — Brett insisted on using the same passage of scripture from the Epistle to the Philippians — and the self. While working on the tasks set, there was an extension into the discomforting zone by breaking established verbal patterns. To complicate matters, Brett would interrupt my delivery and ask questions. Repeatedly this was to break the performance of a well-known piece of text by asking me to consider what lay behind the words. This was more than looking at the deeper meaning of the text. It could probe what my beliefs were. This was a major journey in and through what might be assumed to be simple text work.

The second session began with a more analytical approach that led to a comparatively sedentary exercise. To counter that, there were warming up and physical games and activities. Once again, I felt the exposed quality of doing such work under individual tuition. The corporate nature of acting in theatrical and sacred drama stresses relationship - with other actors and with those there who are viewing it as spectators or fellow participants. I was being asked to look at myself in isolation. Only then could I connect what I said to other people.

The passage was broken into "thoughts" and "series of thoughts". This was to allow a deeper consideration of the ideas behind the words involved. We then spent some time determining what constituted these two elements. Interestingly, this was not always unanimous. In the great tradition of pupil–teacher relationships, the latter's opinion carried the day.

Using the "idea" section, I was instructed to look at the idea, to breathe in, seek to make eye (and mind) contact with Brett, and then say the words.

| equals the thought. / is used to show a series of thoughts. The text was broken up thus:

For us, | our homeland | is in heaven, | / and from heaven comes the Saviour | we are waiting for, | the Lord Jesus Christ, | / and he

will transfigure | these wretched bodies of ours | / into copies of his glorious body. | / He will do that | by the same power with which he can subdue the whole universe. | /

The last section is particularly tricky. Yet, given the time required for the relative depth of the exercise, most work was concentrated on the opening section. As the process proceeded, I would be stopped and invited to explain the meaning of a particular word or ideas. I could use any words to do so. For instance, I was asked what "homeland" meant and I said, "It is the place where one belonged; there was a sense of belonging; you owned the space; you had no barriers between your and others who were there". Having been through this exchange, I would be directed to the thought I had been trying to express by using the word in the context of the passage from Philippians.

Later, I realised there were hidden depths in the exercise. It was not only about text but it included my attitude to it. It is possible to use words like "heaven" and "saviour" without taking into account all sorts of doctrinal and religious assumptions. I also was brought back again to a consideration of my relation to the text. Brett was pointing to some deeply held convictions that were being expressed in my delivery of the words.

This led to a discussion of my personal style and attitude. Once again, I found myself confronting this sense of matters in which I had a non–rational investment. It tied up with some of the blocks I had encountered in my career as an actor. It also shed light on aspects of my emotional and spiritual development.

That was all possible in simply returning to a familiar text. Brett spoke of its use as both a training and rehearsal technique. It could both confront the actor with set patterns of delivery and aid their insight into deeper levels of meaning. It also makes demands on how we relate to others. If one is being repeatedly asked to clarify what we consider rather basic, if not essential ideas, there is a need to be clear and simple. This becomes apparent to both speaker and inquisitor in the exercise.

The third session was likewise sedentary and again used the passage from the epistle to the Philippians. It was a relatively intellectual consideration of physical expression. This drew on the work of psychologist Albert Mehrabian and his findings on meaning and non-verbal communication. Part of this states that very little — less than ten percent — of meaning is conveyed by words themselves. Over half of the meaning is conveyed by facial expression. The next sizable percentage of meaning is transmitted by the way we speak. Brett pointed to three factors in this: the visual (the physical accompaniment by the body to speech), the vocal (including volume, articulation, tonality) and the verbal (the content and the attendant choice of words). This triggered some echoes in using British Sign Language, especially in the area of information expressed in non-manual features. (I am a Stage Two accredited signer.)

With this information in mind we sat down for the next exercise. This included attempts to reflect, without falling into the snare of mere mirroring replication, what another said. I sought to do reflect Brett's mode of expression.

Brett told a story about going to a place in New England in the United States. He described the beauty of the leaves changing into their autumnal colours. He spoke of his wonder at arriving at a breathtaking amphitheatre. He was there as part of an acting workshop with Shakespeare & Company. He spoke of one particular exercise he was called on to do, and how this had opened for him some blocked corridors of thought in his acting style.

My task was to attempt capture his expression in stance, gesture and vocal style. It was more than merely trying to remember and re-present the narrative. It included much more than what I might call the facts of the story. It extended to his physical telling of the tale. Again, it involved more than trying to reproduce his gait and vocal mannerisms. The aim was to try to enter into his form of expression. This has significant repercussions. One becomes aware of the limits of one's own range in the three areas, and how this can be altered to increase effective communication.

Personally, I could not resist thinking about some of my experience as an actor and priest. There is the stark memory of audiences laughing when I was crying in the role of Samuel Parris

in Arthur Miller's *The Crucible*. I had gone with what my feeling as an actor told me was a sincere emotional state. I had ignored, at that time was not even aware of, the fact that when I cry my face contorts into the equivalent of a clown-like smile. It makes people laugh. And that made me cry even more.

There is a less spectacular example in my priestly ministry. I am often thought to be cross or angry. This may come from: a physical swiftness in walking; my not having great eyesight, which is assisted by glasses that form a certain barrier to people seeing my intentions. A singer friend has observed that I do not blink very often. And she says that that gives my visage an appearance of harsh resolution. It is possible to become self-absorbed in this kind of thing. Ultimately, it can only be of use if it is used to reflect on how we speak and are understood. Such information is of great use to both actor and priest.

I was then given the task of trying to assess my own styles of expression. I have already noted some of the reactions I encounter. There must also be a host of others of which I am unaware. If people are intimidated by me, as I am told they sometimes are, they are unlikely to inform me of this. Brett gave me an Expression Profile form. This listed a range of attributes and their expression. They are the expression, with a left to right "score" area:

- Energy, Low to High
- Body Language, Closed to Open
- Eye Contact, Sporadic to Sustained
- Vocal Articulation, Unclear to Clear
- Vocal Volume, Soft to Loud
- Vocal Range, Monotone to Varied
- Verbal Pausing, None to Lengthy
- Vocal Pace, Slow to Fast
- Movement Still to Animated
- Gesture, Restricted to Expansive

The task was to map your self-perception. I was surprised that apart from Body Language and Verbal Pausing, I came out on the right hand side of centre. For an actor such an analysis may be useful in trying to find one's base area. It could, in much the same way as Keith Bain led in his physical monitoring of students at NIDA over the three years of their training, come up with results that signify changes. Some aspects show progress. Others none, or

even regression. It would also be interesting to have someone else, someone who knows you well, to do this. Priests too would benefit in this. We can be surprised to learn that another's perception of ourselves and the way we communicate is at variance to our own.

Actor and priest can draw on three elements — the visual, the vocal and the verbal — in their work. The performance aspects of liturgical and theatrical dramas mean the priest and actor cannot ignore them. These three aspects can be placed in parallel with Stanislavski's three elements of acting: being, pretending and doing. The visual is what we are. The vocal is what we pretend, that is what we put across. The verbal is what we do.

The Church offers those in public ministry many ways to develop their skills. I have been led on training paths of personality profile, learning styles, modes of management, conflict resolution and problem solving. It offers little, indeed, tends to draw back from, criticism of expression in performance. This may reflect a timidity in wanting to challenge set or unhelpful practices in church services. That is a shame. To do so could be very helpful for all involved. And it need not be unpleasant. Colleagues or key members of a congregation could be asked to mark such a profile. Results can be compared. It would be worth asking if some areas can be improved and what resources can be drawn on to facilitate such improvement. (I will explore this in more details later in this book when I speak about developing the third eye.)

The next step

This was work that had much to commend itself. It also led to some serious reflection. I took advantage of the library at NIDA to look at communication, drawing on the works of several big names in acting and acting training. Their views on what aided or impeded communication. I looked at the work of the renowned voice coach Cicely Berry. She is scathing about those who would let language speak for itself. Performers, she rightly asserts, have a responsibility to the words they are called on to proclaim.

The works of the anthropologist Victor Turner, especially his work on ritual and theatre, became a key source for reflection. His views on where performance and ritual meet on the edge – liminal or liminoid – has much to offer the priest and actor. His continuum of play, through games and sport to theatre and ritual

might be understood personally as well as socially. He has much to say about the importance of visual messages adding to what is spoken. In many ways, these observations should not be startling to anyone involved in the presentation of plays or church services. It is a shame, then, that more people do not give attention to this.

All these thoughts were fine enough for me in the library. What would matter was how they might apply in reality. The challenge would be to move from thought to action, to close the books and encounter the difficulties of seeing the ideas applied. That was where the next two sessions in the rehearsal room would attempt to do.

Chapter Six

Word And Deeds

Part One

Despite the useful explorations of the first three sessions, I was becoming anxious that we focus on some of the set pieces of church performance. This could be seen as part of my controlling nature. But it was also a realisation that all rehearsal time is limited. Because of this, I suggested that Brett and I concentrate on two matters that I considered important. We were to do this in two ways, which would mirror the two main aspects of liturgical drama – word and sacrament. The 1662 Book of Common Prayer catechism asks the question of those preparing for Confirmation: "What meanest thou by this word sacrament?" It helpfully provides an answer which states that it is "an outward and visible sign of an inward and spiritual grace".

Before this definition, the BCP lists "two only" of these signs as ordained by Christ — Baptism and Holy communion or, as it terms it, the Supper of the Lord. Catholic tradition expands the list of sacraments to seven: Baptism, Reconciliation, Holy Communion, Confirmation, Marriage, Ordination, and Anointing of the Sick. It would be impossible to do all these in the rehearsal room within the time available. Brett and I would concentrate on the performance aspect of the priest's role in these sacraments. This would have to be done by reducing matters to key points in the sacrament. After some discussion, we decided to concentrate on prayers that are used in the sacraments of Holy Communion and Baptism, the Eucharistic prayer and the prayer over the waters of initiation. We did them in that order. That would allow us to focus of words and deeds.

There are five main components, usually termed actions, in the celebration of the Eucharist: the coming together of the worshipping assembly, listening, remembering and giving thanks, sharing and going out. There are more churchy terms for these actions: Gathering, Liturgy of the Word, the Eucharistic Prayer, Distribution and the Dismissal.

To a certain extent the work I had done with Brett had already covered some aspects of all these actions. What I wanted to

concentrate on was their application to particular facets of the priest's performance during a service — the sermon and the Eucharistic prayer. I felt sure that by subjecting myself to the scrutiny of a director I may enter hitherto uncharted waters. There could be applications for myself and possibly for others. I was not to be disappointed. We decided to do the Eucharistic prayer first.

It should be noted here, as it will be elsewhere, that there may be many ways to stage the Eucharistic prayer. Varying texts allow for a range of involvement, from a priestly monologue to a dialogue between priest and other members of the worshipping assembly. Selection of texts for use can draw on various processes, from the dictatorial to the consensual and anything in between. At St Matthew's, Bethnal Green the Parochial Church Council had, when it deliberated on the implementation of the latest series of services under the Common Worship headline, decided that the Eucharistic prayer should be, by and large, recited by the priest alone. It was this, in the form of Prayers A and B, that I brought to the rehearsal room.

The room was arranged with a table, like an altar, between Brett and me. On it was simply placed a piece of paper as the prop for bread and a cup for the chalice. The opening dialogue –

Priest:	*The Lord be with you.*
People:	*And also with you.*
Priest:	*Lift up your hearts.*
People:	*We lift them to the Lord.*
Priest:	*Let us give thanks to the Lord our God.*
People:	*It is right to give thanks and praise.* [5]

– caused the first problem that any actor will recognise. There was no–one to bounce the lines off. The director was watching the process and to call on him to deliver the responses would be to distract him. After all, each of the lines by the priest, as least as I do them, has a different accompanying gesture of arms and hands. I was concerned more than Brett was about this. In the end, I just imagined a response, a bit like doing a one–sided telephone call on stage – allow yourself time to hear the response from the person at the other end; don't rush to your next speech.

Getting me to look at the task in hand was sufficient for both of us. He asked me just to run through the entire prayer, complete

with the hand gestures as I would do them, from start to finish. I did. A long pause. Not even an "Mmm." He got me to start again. I did not get far. Thus began a series of inspired interruptions. Brett asked me to remove all gestures from the prayer and simply direct my attention to him and say the words. We were once again on the lines of clarity. A number of variations and distractions followed.

Variations on a theme

Perhaps the most challenging was to recite the prayer as if it were a children's story. This, of course, is fraught with danger. There is a temptation to tell a story to children, especially if there are no children present, as if they are mentally deficient. An actor can find herself becoming a clichéd nanny figure – Mary Poppins, eat your heart out. That is why the places on Playschool are so sought after. And why getting those jobs and doing them well is so difficult. You have to relate to the camera as if it were a child, as well as be engaging those beyond it, without being insultingly patronising. You have to be able to let your openness communicate to the unseen children watching. That will allow them to interact with you as you do the action songs, or get children to go with you through one of the geometrically shaped windows.

Knowing some of these dangers from the reports of friends who had made it on to the set with Big Ted and Little Ted, I held back. A mistake. The director wanted me to extend, to the point of caricature if necessary, the elements of story telling. It became challenging indeed when it came to the "holy bits" of the words of institution, i.e. when the priest recites the stage directions and reported words of Jesus over the elements of bread and wine:

...who, in the same night that he was betrayed,
 took bread and gave you thanks;
he broke it and gave it to his disciples, saying:
Take, eat; This is my body which is given for you;
do this in remembrance of me.

In the same way after supper
he took the cup and gave you thanks;
he gave it to them saying:

Drink this, all of you;
this is my blood of the new covenant,
which is shed for you and for many for the forgiveness of sins.
Do this, as often as you drink it,
in remembrance of me. [6]

I was, perhaps naturally, reticent.

"Don't worry about it!" That is what directors say when they are working on something beyond the words being used. They know actors are concerned with where rehearsals are heading. At this stage, however, directors are keen to concentrate on the process which may, or may not, have a beneficial effect on the product. What it needs is co-operation from the actor to put aside the concern for the finished product. Only by doing this can there be a true exploration.

Sometimes this is done to allow an actor space to discover something behind the words. Often such techniques are merely part of the rehearsal process. The games and variations are abandoned as the opening night moves closer. There are exceptions. There was a stunningly fresh and vivid production of *Much Ado About Nothing* in the 1970s that started its touring life at the Nimrod Theatre in Sydney. During rehearsals one day the director John Bell asked the cast to speak the lines with "Italian greengrocer" accents to loosen any sense of formality in approaching Shakespeare. The effect was so electrifyingly fresh that it was retained in performance.

I was not being asked to anything quite so daring. By pushing to an extreme the words of the story – after all, it is called the institution narrative by liturgists – I found myself understanding parts of it anew. Not only was being asked to tell it like a story but Brett would occasionally interrupt. "I don't understand," he'd say, and my response for hoped-for greater clarity had to be couched in the very words with which I had just veiled the meaning. This process can be enlightening. Often it can be used to tear the sentimental and intellectual wrapping around something precious. Elevation of thought and language can sometimes restrict accessibility. By shaking up the accepted delivery something new may emerge. If it works for Shakespeare, why not for liturgy?

The question then returns to one of clarity of intention. If you know what you are saying, are confident that you have explored

its fuller content, then you communicate it clearly. The next target would be what are known as manual acts. I have earlier referred to these as gestures. Quite simply, these are what are done with the hands. There is a weird and wonderful range of these to be seen within the church. I was expecting some rigorous examination of what I do and why. This would be in keeping with Brett's style thus far. And it would, as I admit in the chapter Lifting Holy Hands, reveal some of the peculiarities of my own of which I am aware.

Oddly, most of the gestures went unquestioned. Brett's insistence that I use all usual gestures meant that for most of the time my hands were in the *orans* position. My arms remained in that position, having once picked apart and reconstructed the texts we were looking at for the best part of an hour. As is often the case when performing, this did not matter at the time. It was only later that I realised my arms were sore.

After we discussed some of the process that we had been through, Brett asked to hear the prayer over the water from the Baptism service. The authors of the variant aspects of the prayer deserve to be congratulated. It has the elevated cadences required for such an occasion, but manages to do this in seemingly normal language. This is achieved by small adjustments in event and prepositions, such as relating how water figures in key moments related in the Bible:

Over water the Holy Spirit moved in the beginning of creation.
Through water you led the children of Israel
from slavery in Egypt to freedom in the Promised Land.
In water your Son Jesus received the baptism of John
and was anointed by the Holy Spirit as the Messiah, the Christ,
to lead us from the death of sin to newness of life. [7]

Similar variations on a different theme then occur when the priest is called on to relate water to the worshipping life of the Christian community:

In it we are buried with Christ in his death.
By it we share in his resurrection.
Through it we are reborn by the Holy Spirit. [8]

I love saying this prayer. It is a clear example of a successful marriage of elevated and approachable language. It is a combination, I believe, that is painfully difficult to achieve. And the Church of England, which is often accused of many things, needs to be told that it can be rightly proud of this text. For all that, there is a significant movement to rewrite this text as it is considered by some to be "too wordy". That many priests fail to use it with the dignity of the language is a shame. And, thankfully, it was not what Brett Wood was asking me to attack or defend.

Knowing what Brett did not — that I thought this was one of the jewels in the liturgical language crown of the Church of England — I was keen to do it well. I placed my arms in the *orans* position. I recited the prayer. Another long pause. Whoops, I thought, I am for the high jump on this one.

"That really is a wonderful prayer. Beautiful." And?, I thought. "And there is nothing I feel I need to say about it. I got it. I got it all." "Phew", thought the performer. That four letter word carries a raft of meaning. Before stepping up to the plate of rehearsal, an actor can be fearful that his preparation will be torn to shreds. After all, he never really knows the angle or obsessions of the director. I have been alternatively praised and badgered for efforts in rehearsal rooms. But every now and then it has a different gloss: what you have done is considered just right. There is really nothing more to say. Somehow you have captured all there was to be expressed. And the director wants to acknowledge that. It was my impression that this was what Brett meant.

Something of the process must have made its way into my skull. Or my body. And the latter was telling me now: keep your arms in the *orans* position for nearly an hour, and they are bound to get tired.

Chapter Seven

Word And Deeds

Part Two

The second session on liturgical set pieces was devoted to what some people think is the most important part of the priest's public role, preaching. While it may be a set piece, it has great variation. Once again, it is worth noting that there are several ways of preaching. Some parts of the church have a very restricted, if not self-inflated, view of preaching. I know of one London church that effectively gives a preacher a week to prepare a sermon which is expected to last for at least forty minutes. The preachers see it as a stand alone task, the vital work of the ministry, and draw on biblical texts to support that view. This is not the place to analyse their views on the Bible or claims of bibliolatry from their critics. I just want to stress there is a breadth of views.

There should, to my mind, also be a breadth of preaching. Sadly, some parts of the church again have a very constraining definition of preaching which does nothing to achieve this wideness in the word's mercy. This definition extends to content, method of exposition, illustration and style. From time to time priests may be called to assess college students on their preaching. The assessment form that is provided is usually a good indication of how wide or restricted a view the training institution gives to these matters. As the Church of England bishop, Hensley Hensen, is reputed to have said:

> *There are two kinds of preachers: one who has something to say;*
> *the other who has to say something.*

The extent of scope is also personal. It is generally considered that most preachers have a limited range of styles. A friend once told me he never listens to his parish priest's sermons. Noticing my shock, he said, "I know what he is going to say and I know how he is going to say it. He is a good man. But he only has one sermon. The presentation is just a variation on a theme." The general view among preachers is that people have up three or

four styles. This is considered a good range. A colleague of mine claims that I have repeatedly flummoxed her assessment. If she is right in saying that I have a wider than normal range, I could only look to experience: as a broadcast journalist, as an actor, as a priest. The maxim is simple: make sure people listen.

The former employment in radio and television taught me that it was important to write text that was only intended to be read aloud. It does not matter if it fails some more formal assessment. It is not intended for publication; it needs to be understood when said. Anyone who has made the transition from print to broadcast journalism, or the reverse journey, will know they require different skills. Spoken can text can — and probably should — take liberties with grammar. All sorts of rules can be broken. Sentences need not contain verbs. Indeed, rhetoric almost demands that matters of syntax are often surprisingly unresolved. If not totally ignored.

For all that, I expected this session in the rehearsal room to be one of the easiest. I came to it, as they say, with baggage. I had sent the text ahead to Brett. I had chosen a sermon I had preached some months before, one which looked at a passing phenomenon, as they all are — that of the corporate wrist band, especially one of its Christian manifestations that had WWJD on them. (WWJD = What Would Jesus Do?) The sermon combined some anecdotes from our church school and my family background to look at the difference between hollow preaching and faith in action. It drew on the actions of Jesus, and how they outraged many faithful people of the time, to suggest that much of what is assumed as evangelism is directed within the already Christian community. It should be an outward drive. And it need not advertise its source.

I thought I was familiar with the text. I assumed, having preached the sermon in church, that doing this in the rehearsal room would be a relatively easy task. I was wrong. It turned out to be something of a disaster.

The first problem came simply. I had a text. I was used to placing this on a lectern. That would allow me not to hold the paper, to give my hands freedom for expressive gestures should I consider them necessary and, in a strange way, to hide behind. There was no lectern, not even in the form of a music stand which might have been presumed to have been somewhere to hand in an acting school. We had to make do.

Making do is no bad thing. Actors are required to do this routinely. Only suggestions of the most complicated set, for instance one requiring several doors for a farce, are available in the rehearsal room. Windows, doors, even steps are usually indicated by lines, in the form of gaffer tape, on the floor. Furniture is often wildly at variance to that which will appear on the dressed set. Women often resort to rehearsal skirts if a period piece is being performed. This allows them to acclimatise to the flowing fabric of the time in which the play is set. A woman in a boned corset does not move in the same manner as one wearing jeans.

Adaptability and invention are required. I did my best to find those attributes. I stacked one chair on another. I then inverted a third so that the seat of one rested upon the back of the two. This was to give me provide the place for the text. Behind my Dalek–like structure, I was ready to do the first read through. I think a good text — I did think it had value — had never been delivered so ineptly as it was that day.

A unique event

There is something unique in every public performance. Even a play that is in the midst of a long season is, in some ways, new every time the actual or proverbial curtain goes up. The particular combination of cast, crew and audience in a theatre at any given time cannot be repeated. Even if all the human elements were the same, a second performance would be different from the first. The bringing together of text, delivery and reception at a given point is properly ephemeral. The same is true of preaching. Indeed, much is rightly made of this. That is why reading the text of what seemed an impressive sermon can be an anti–climax. The ringing cadences of delivery, the import of ideas, the effect on the congregation, are all lost. Sometimes what is left for later analysis seems relatively dry or thin. Likewise, an extraordinarily good text will be contrasted with a lacklustre delivery.

It would be handy to have been able to draw on this reason for my inept delivery. The circumstances, however, were much more mundane. Quite simply, I could not read properly. Despite being in that situation, I foolishly tried to press on and make good my visual shortcomings. I strayed from the text. I waffled. I fluffed words, I stumbled over ideas. I would look up and when I looked

down I could not find my place. I would have to bend over to bring the glasses – I wear bi–focal spectacles – on my nose into a proximity where I could make some sense of the hazily dancing hieroglyphics before me.

At the end of an awful run–through an actor does not need to be told. She usually knows. A good director will somehow affirm the paucity of the run but will find a way to make it contribute to the bettering of the next run and, in the end, a good performance. Brett knew what I knew. He had the forbearance not to state the obvious. As many a director before him, he diverted my attention.

I was reading the script. This was obvious. Instead of trying, as I was, to link each thought with the page and the people (imagined or real in Brett alone) why not make a virtue of the fact that I did not, could not, have learned the text by rote? Read one sentence aloud and pause. Don't pretend you are not reading. Look at the next section, read it without speaking to the end of the next sentence, then look up. Speak the text. You will remember more than you think.

It was true. I had taken my eye off the performance ball. I had tried to cover too many angles and, as such, delivery failed. By giving only a halfway nod to the declaiming of the text, it had become muddied in both content and delivery.

There is a way to turn such disasters around. Effectively, this would make a virtue of the nature of the event. Brett had some advice. Do not be afraid to pause, he said. It will allow people to take in the thoughts, which to you are familiar, that you have just given them. They have never heard them before. Unlike you, they do not know what it is coming next. Allow them time and space to catch up.

A map of ideas

Having done this for half the sermon, it was clear that my familiarity with the text was being restored. I was also regaining my confidence. Having hauled me from a pit, Brett was then going to set me at the edge of a small hole. Drawing up a chair, he showed me a technique that could be used to secure thought processes for those making public presentations. In effect it was to draw a map of ideas. With a gently curving road from the bottom of the page to the top, we marked the journey of the sermon. Every here and

there were little stops, not quite diversions, more resting places just off the main road, where illustrations, anecdotes or variations on the theme could be highlighted.

This then became the basis of the sermon. I was sent out into the middle of the room, holding just the map in my hand and was given the task of preaching. This I did from start to finish. I found that I could recall entire chunks of text. Likewise I could provide an illustration with a seeming freshness. Being released from the crafted, pored over or perhaps rushed–in–the–writing text, I could let the ideas breathe.

That is not to suggest that it was an unfettered success. In some places precision suffered at the expense of spontaneity. Like the proverbial shaggy dog story I worried where my thoughts were heading. But even this adverse aspect had its lessons. Knowing the shape of a scene allows an actor room to develop the actions, activities and relationships required to make it live. Knowing the shape of a speech allows the performer to decide how to use his gifts or training to make clear the intent.

At this point Brett led me to a consideration of various actions in the sermon text. I should make it clear here that I am using the term action as an actor would use. It is more akin to the intention behind the act of speaking. Transitive verbs are the stuff of theatrical action: appeal, convince, rebuke — these are our actions when we speak. This can provide an actor a way into a speech. Instead of just learning the lines, the emphasis moves to understanding what the character wants. The action is what is done to achieve this.

A tried and true task in the teaching of homiletics is to get the preacher to write a sentence of what she is trying to achieve in the sermon. Many fall at this hurdle. What people tend to write is what they think the sermon is about. The challenge is to express what it is trying to do.

The exercise was a good reminder that action follows reflection. The popular illustration of the circular process of activity leading into reflection, theory and planning only to start again at activity is instructive. I thought of Tom Morris's Keatsian dictum, designs on the audience, and realised that preaching had this element to it.

In some forms of evangelical preaching there is an expectation that there will be an "invitation". This has its classic expression

in the large rallies that used to be presided over by Billy Graham. People would be invited to come forward to make or renew their commitment to Christ. This was seen as a life changing event. Having committed themselves, the newly converted were expected to act in accordance with their commitment.

The session with Brett that day was exhausting. Repeatedly going over 15 minutes of words was more difficult than the shorter pieces of text we had concentrated on in other sessions. It presented the challenge to preaching. More preparation, and I do not mean intellectual, is required. I often stop and read aloud a line when I am writing it. The best test as to whether it is easy to say a line is to do just that: say it. Many a finely crafted sentence on the page sounds clumsy when it is spoken. Rules can be broken in the service of clear delivery. I have already noted the variance of practice required for material to be spoken and heard from that which is to be read in a book.

I try to rehearse a sermon from a pulpit at least once before its actual delivery. This is not always practical. If one is visiting another church as a preacher it is sometimes impossible. Yet if one can, I believe one should. These thoughts are taking further in the chapter entitled, When Speaking In Church (Or More Generally Things to Bear in Mind before Opening one's Mouth in Public).

Not only had I tired myself with the work in this session, but I had to acknowledge that my experiment had come to an end. It was almost inevitable that I would consider myself on the verge of more challenging work when our time was up. The first couple of sessions had set the scene and allowed what seemed to be intense work. Of course, more could be done. That, I knew, was up to me. What I did with the experience and where I went with it was the task in hand.

Afterthoughts

It was inevitable that this process of removing myself from the familiar to engage with aspects of liturgy would give rise to some reflection as to where the theatre and the church might learn from each other. Some of what follows is informed, some is researched and some is purely personal. Some of it is immediate and some is the result of extended reflection. I offer it as part of the journey that took me from the sanctuary to the rehearsal room. For part of the time of writing this, I was about to embark on the return leg. For other sections, it was after an extended period. So, ladies and gentlemen of the reading cast, this is your standby call …

Chapter Eight

Priest and Actor

Let us start with the obvious. Both priests and actors exist in themselves but not for themselves. Lest anyone think this is a Sartre–like existentialist distinction, let me be clear that it is more a matter of intent and relationship. That is to say that the focus of the work of actors and priests should be beyond themselves. Actors, while appropriately self–concerned, should not be self–obsessed. If they are, they can not be good actors. The same argument holds up for priests. Priests are rightly concerned with their own spiritual health and welfare. Yet if this is to the exclusion of others, there is a risk of a retreat into pietistic egomania that is of little use to the people a priest serves.

There is a slightly self–congratulatory gloss to the preceding paragraph. Since its original casting, Pope Benedict XVI designated the twelve months from June 2009 was as the Year of the Priest. In the posters around the world to support this initiative – no doubt to recruit more men to the thinning ranks in the west, and encourage others on the vocational path and to bolster those where their numbers are booming – was a quote from St Jean–Marie Vianney, the patron saint of priests. I saw it on posters and banners in Germany, France, Belgium and Italy. In English it is usually rendered as, "A priest is not for himself. He is for you".

However, there is a need for some regard to self. It should come at the end of a hierarchy. Ironically, in the training of both priests and actors it is often the concern for self that precedes consideration of others. This may be appropriate in training but it cannot hold for the work of performance. It is incumbent on those responsible for training in both fields to broaden the horizons of those who will stand in front of audiences and congregations.

There are three aspects in common to the work of actors and priests:
- relationship to others
- response to text
- appropriate personal self–attention

Relationship to Others

Other people are essential to both callings. As John Donne wrote that no man is an island, so no actor exists without an audience. In the theatre this is immediate. At a live performance people can be seen, heard and intuitively sensed. The emotions and reactions of an audience can affect the performance of an actor. Indeed, they should. Laughter is a simple illustration. The number and size of laughs impinge on the actors whose task it is to make clear the situation, relationships and dialogue being enacted. This, in turn, has a determination on the text being performed. The actor who presses on with the script can lose the audience when it is laughing at a joke. Plot, set–ups for the next laugh line, even the gag that has been delivered, can be minimised by such a bulldozer. A superb illustration of this in the character of Brooke Ashton playing the role of Vicki in *Nothing On*, the play within the play *Noises Off* by Michael Frayn. She knows her lines, she doesn't care that the play is falling apart, indeed may not even be capable of noticing what is going on. She is going to deliver her lines as rehearsed and in the original order. As such, the spectacle is nothing short of hilarious.

The same applies to drama. You do not expect people to react to a light or clever comedy in the same way as they would to *King Lear*. There is a relationship between players and those who have come to witness the play. The horror of the plucking out of Gloucester's eyes is profound. Audiences will dictate how effective this gruesome act is. To rush or pause too long can destroy the reaction. The actors playing Regan and Cornwall need not only to be aware of the technical requirements of enacting the barbarism but also to gauge the response of those viewing it.

Sheer numbers can also have an impact. There is a tangible difference between performing to a small audience and playing to thousands. Different resources are required to be heard, seen and understood. These resources should be part of the training and skills base of the performer. It is unpleasant for an audience to feel shouted at in a small venue. In the same way physical strength is needed to project to the back of a large theatre. Whispering in a cavern defeats the purpose of being on stage. An otherwise great performance can be undercut by either shouting or underpowered vocal delivery. Once again, there should be a process of both self awareness and external feedback.

Sometimes an actor will be so inside a performance that the audience, and sometimes even fellow performers, feel excluded. They are concentrating so much on the task in hand, perhaps in trying to stay "within" the character, that they lose the very purpose of performance: to put a play over to those who have come to assist at it. This can be captured in the barbed criticism to the question, "What was it like?", "Oh, they were having a wonderful time on stage; the audience were the ones left out."

Space itself can demand changes to the way an actor approaches the task in hand. Performing to an audience of twelve in an intimate space can be engaging for both actor and viewers. Such intimacy would be impossible to achieve with a similar number in a vast auditorium that could accommodate more than a thousand. Those who have performed in plays that have bombed have endless anecdotes of the trial this involves. The Full House sign is more than an indication of good business. It is a tonic. Enthusiasm can bubble over into both sides of the arena.

It is worth noting that not all relationships with the audience can be sensed on the spot. Technology has created, and continues to create, a number of exceptions to this interchange across the edge of the stage. There are times when this immediacy is not immediately apparent. Actors involved in television, film, radio and the internet do not have that contact with those watching them. Yet the audience cannot be entirely forgotten. Actors rely on others, especially the director, to point to the effect that has to be imagined or assumed.

The same factors attendant to a performance hold true for a priest. There is a congregation before the priest. One may hesitate to suggest that one *performs* for them but let us use this term in a broader sense than that caught in the expression of "playing to the gallery". A congregation can be encountered. People can be sensed intuitively, heard and seen. Priests need to be aware that they do not act in isolation. Others' emotions can affect their own. Any priest who has presided at the funeral of a child will know this well. It is thus apparent that the nature of the occasion affects the presentation of the priest. A baptism, wedding and joyous feast each has a distinctive aura. To ignore the way those who have gathered to celebrate these occasions is folly. Such events draw a predictably different response from funerals, which have an entire

range of affective circumstances, including the age of the deceased, the relationships between the departed and those who have come to the service, as well as the facts of how death was met.

Likewise, the priest must make certain performance decisions: when to allow space for people to go with the swelling emotion, when to override it, when to intervene or hold back. There are simple parallels in laughter and more sombre emotions. The priest needs to take them into account as whatever message is being presented requires skilful delivery. It is not good enough to rely solely on the written words.

There are also occasions for both priest and actor to distance themselves from the state of those watching and participating. This is to allow a proper focus on the task in the actor's or priest's hands. Those who have gathered for the occasion, be it religious or dramatic, are occasionally better served by such a distance. Sometimes this is as simple as a mental "stepping back", leaving emotional response to the audience or congregation, to allow the performer to focus on shape and delivery of the occasion.

Response to Text

The relationship between actors and audience can, to some degree, be the result of factors beyond their control. The material being presented mediates the nature of the contact. Much of what is performed by both priest and actor has been scripted. There are occasions when the performers are called on to deliver something from themselves but generally there is a text, be it a play or liturgy, that is being enacted. (This has an hilarious exposition when "Sir Ian" played by Ian McKellen explains his "method" of acting to Ricky Gervais's Andy Millman in an episode of the television series *Extras*.) When actors are not performing something written for them, it is not surprising that what they say may seem relatively vapid. As the humorist Guy Browning points out, when they are on stage actors' heads can be filled with some of the most sublime sentiments expressed in language. So it is not really surprising that what they come out with in the bar after a play is pretty paltry by comparison.

Mention has been made of bulldozing text. That is why Brooke Ashton as Vicki in *Noises Off* is so funny. Preparation is required. It should go without saying that priest and actor has looked over,

or even knows by heart, the material that is being presented, that its resonances have been dwelt on and exemplified. If only this were the case. I have seen a priest reading the Eucharistic prayer during a celebration of Holy Communion as though it has never been in front her eyes before. This could have indeed been the case. It should not be. A priest needs to be aware of anything that might be unfamiliar. It is the responsibility of the performer to know what is coming. It is, ironically, that which can give rise to spontaneity. That is part of the service involved in priesthood.

There is a more profound aspect to this. Performers have a responsibility to the text. In the case of actors, their roles only make sense in the unravelling of both plot and circumstance to relate the themes of the piece. In most cases a writer has worked long and hard to provide the scored elements of the play. Play texts are like musical scores. Without a performer and instrument the music is unheard. The player has to work hard to ensure that manipulation of instrument allows the piece to travel to those listening. If they do the work properly, it will be held and recalled long after the immediacy of performance.

To that end, a performer's job demands familiarity with text. The extent to which this is possible can vary greatly. Someone reading a eulogy need not have learned the speech by heart but should at least know the shape and flow of the address. This can only underscore the intent. An unfortunate occurrence for some priests at a funeral is the "poem" written by a family member. A piece of paper is thrust into the hands of the officiant as the coffin is about to be taken into the chapel. At worst, these can be a calligraphic challenge to the reader. They may be handwritten. Discerning what might be contained within the ideographs is a test in itself. Computers have improved matters, but not entirely. There are also peculiar variants to received spelling and grammar. This leaves aside unique views on rhyme, metre, scansion and form. The family often treasures such a personal contribution and it is appropriate that it should be presented as well as possible. Even if the script had been given only a few hours before the service, the chances of a coherent delivery are greatly improved.

Such matters take on an even weightier consideration when it comes to set pieces. An audience would be rightly outraged if the actor onstage playing Hamlet knew the famous soliloquies less well

than his auditors. It is a truism, but one worth repeating, that near enough is not good enough when it comes to learning lines. Faulty memory causes unwarranted burdens to fellow actors, as I know to my personal shame. If it had not been for the rock of a fellow actor, Andrew McDonald, I would not have been able to make it through Act Three of *Look Back In Anger*. It was a humbling lesson. A writer has provided actors words to play, not to play with.

The great Eucharistic drama of the mass is similarly dependent on the priest knowing the part. If celebrating a variant rite – and there can be many variations – the congregation deserves the preparedness of the celebrant. I have cringed with embarrassment when watching, and knowing myself to have been guilty of having done it myself, a priest launch into the recitation of salvation history only to lose the place. It becomes a compound crime when the celebrant realises that not only have the words been forgotten but also the altar book is not open at the appropriate page and, to further compound the criminality, the requisite knowledge to locate the necessary page is temporarily unknown.

A similar caution should apply to strange surroundings. Actors in a touring company will, or should, insist on seeing the space on which the play is to be performed before the curtain — real or metaphorical — goes up. The proximity of the audience, the acoustic, physical adjustments that may have to be made to accommodate the set, the rake of the stage or supports for the set: all are germane to the drama. Any or all of these elements can alter the three hour traffic of the stage.

Priests who are conducting worship in a new space for the first time should exercise similar caution. There are no end of traps in the form of pieces of carpet, secret steps, hidden microphones, varying heights of altar, chair or bench. The dignity of the celebration cannot help but be affected when a priest sits only to find knees are higher than nose, or by a pratfall in the middle of the gospel procession.

Appropriate personal self–attention

This third aspect in the hierarchy of approach is the concern of much of this book. Acting, arts and design schools are filled with would–be artists whose concern seems to be less on the making of art as the justification for an individual's being. As

such, they expend much energy on the ego at the expense of using a medium for its expression. Would-be priests can be accused of a similar misplaced emphasis. There is a trend among those coming forward for ministry to dwell on the need for affirmation of an individual in what has been done in the past or is being done now. This has two projected flaws, the first being a view of priesthood as a form of personal development. The second is that it places the emphasis on the person of the priest instead of the work of service required of those in public ministry – though it needs to be stressed that both life and work are important. It might be argued that both these manifestations of self-improvement are symptoms of a larger social disease: one that has moved from the aspirational to the masturbational.

There is a happier view. This entails the acknowledgement of the appropriate process of those who would appear in front of others, or would have their displayed to the scrutiny of critics and public alike, need to move through a stage of self-attention. There is a similarity in the classic formula of training actors and priests. To generalise a three year programme is to divide in to three stages:

- breaking down
- reconstructing
- polishing

Many would question this method. I simply state it as an observation of a process in both fields. To concentrate on the training of an actor, the first stage is one where the trainee's native talent is put under repeated pressure, where questions are asked to probe behind the natural exterior. This can have a demoralising effect. I have witnessed this in the training of one of the most talented actors I have seen. After a stunning audition to gain admission to a course, she became almost helpless as her self-confidence evaporated during her first year at drama college. I am pleased to say she recovered and went on to a deserved successful career.

One might want to question the methodology of robbing a performer of self-confidence. Similar traps are encountered by those who think they are in more cerebral territory. Many tales are told of the fervent believer whose faith falls apart in exploring the discursive nature of biblical criticism. What was accepted as a basis for personal faith is put up to question. Which of the variant

versions of the Bible is correct? Did these events recorded in scripture really happen? Are there social or historical factors that need to be taken into account when speaking about a text? The first of the three stage training programme is at work again. By questioning the very basis of faith, it is hoped the student will be of service to others who experience qualms and doubts. Certitude is not the only response to the explorer. Indeed, it can often have the regrettable result of closing a door that was ajar in questing.

Actors and priests need to know themselves. They should be aware of their strengths and weaknesses. Being aware of them, they need to judge whether it is appropriate to play to one's strengths or lay open one's weaknesses. The simple word involved in this is honesty. Priests and actors need to honest with themselves to allow themselves to be honest with others. To be honest involves a range of skills, processes and techniques. It is not necessary for us to list these here. What is at issue is the awareness of whether they can be used for others. Just because one has done some therapeutic work on one's past does not necessarily mean that therapy is an appropriate tool for others. It must be put in to personal context. Such appropriate judgment is, unfortunately, not universally applied. One size does not fit all.

Any process of training or study should have the goal of the tasks expected at its end. It may have many stops and diversions on the way, but the primary purpose is that of preparation for work. It may be that one will discover, explore and challenge aspects of one's personality and traits on the way, but this should be for the improvement of technique. All else is self–indulgence.

Much of what follows is a consideration or meditation on the hierarchy of three aspects explored in the hierarchy that leads to performance of priest and actor:
- relationship to others
- response to text
- appropriate personal self–attention

Chapter Nine

The Holy Space

An actor, on a touring production, arrives at a venue she has never been to before. She looks it up and down, bounces a few words and sounds off the wall. She clicks her fingers, stamps her foot. She nods approvingly and then says to the bewildered key holder, "It's a good space."

What happens in a space can often be determined by its boundaries: the textures of the furnishings, the view from the seats, the height of the ceiling, the distance between performer and spectator. If these relationships are right, a major barrier is removed. The audience will think less of the problems in watching and more about the themes of the play. If they are wrong, the production has its work cut out just to survive.

Not all spaces – theatrical or ecclesiastical – are adaptable. Not all of them are actually suited to the performance of theatrical or liturgical drama. A passion to present either plays or liturgy in unusual places can die simply because the venue is not suited for what is being presented. Needs and preferences compete. Sometimes it is an unevenly matched bout. The issues can build up until the mismatch hits battle fever pitch.

The church is often at war with itself. This goes beyond the "normal" battles that follow judgment against those whom one section considers short of the exacting standards that it claims for itself. Such disputes have diverse roots: gender, doctrine, interpretation of scripture, sexuality, styles of music, orders of service, the use of technology, personalities and issues, like those within families, that have been long forgotten except for the fact that one member recalls that one should not talk to the other. These issues are part of the fractured corporate life of Christianity. Despite much hand–wringing and lamenting of these "sad divisions", most battalions are more than pleased that the platoons which have reformed from their ranks are no longer form part of *their* Church Militant.

Rhetoric covers much. Actions can as well. Most churches are adept at hiding controversy from the casual visitor. They sing hymns with lines that refer to those who have strayed: "O

bring them back, Great shepherd of the sheep". In doing this, there is a risk of corporate delusion. One avoids the reasons for division. Not that one has to work too hard to attempt to embrace a reformed unity. After all, if your view was one that was not accepted among a predominant group of people, or if the leadership had anathematised such an attitude, you probably would have excluded yourself already.

Some churches have a rich history of conflict. Someone will consider that their ministry has not been endorsed or respected, or their vision has not been embraced, as the individual considers appropriate, so they leave. In London, in parts of the Pentecostal movement, churches reform and regroup like characters in a computer game. An attacker presents him- or herself and the opponent starts breaking up so there are more participants in the battle. Initially these battles are mostly personal. Yet they can develop and become institutional. Sometimes a new church, which could consist of no more than an aggrieved member and a sole supporter, adopts a name to define itself against the church from which it splintered, such as the Real and True Church of the Whatever the Original Title was.

Mainstream churches suffer similarly. Many regular worshippers would be hard pressed to explain the historic divisions between the eastern and western church, let alone the subsets of controversy within each. Disputes about the *filioque* clause in the Nicene Creed, validity of orders, the nature of authority, what constitutes the proper conduct of which rite by whom – there is an exhaustive mine to quarry.

There is, however, another sort of warfare. It is a truly physical battle. The gathered worshipping community, sometimes with the collusion or opposition of those responsible for leading it, is at war with a building. This can be more than just the external structure in which people gather. It includes all sorts of aspects on and within them. There are original, corrupted, adapted, mutilated, and avoided elements. These can be such items as banners, furniture, memorials, donated items, plaques and fittings. Or they can be more literary: superannuated hymn books, pensioned off orders of service, Bibles that have found their way to the church after the death of a parishioner, notice sheets dating back to the Ark, posters for events long gone, books unread and papers forgotten,

abandoned or ignored. There might be piles of children's activity sheets, left in the vain hope that they mattered enough for the individuals to return and reclaim them. An adult could turn up in years to come to retrieve his Sunday School work.

<div align="center"><i>Treasure or trash?</i></div>

Some churches house an Aladdin's cave of toot. This treasure trove of junk is stored in the misguided belief that it can be used somehow to further the Kingdom of God. On arrival at St Matthew's, Bethnal Green, I discovered cupboards full of detritus. When I exclaimed my surprise, I was informed that this refuse was kept for the raffles and jumble sales. Such activities in the past had not endeared themselves to me when I served other churches. Great enthusiasm would be shown before the event. Of course, no sale of this sort clears all the tables. Leftovers would be left for the clergy to pack up and store or dispose of. In one church where they did pack them up, unwearable rubbish would be black-bagged for storage until the next sale where the same items would be put on display to remain unsold. The gallery of another nearby church was an unofficial self–storage centre. Any old rubbish that was no longer welcome in the household could find a home in the house of God. My response to the projected sales and raffles at St Matthew's was to declare an immediate ban. The enthusiast took umbrage and announced his departure. I think he left two other churches after that, though probably not over the same presenting issue.

In this small skirmish lies the essence of much of the problem. What is a church for? There are many responses to that question. I want to suggest one. It is for liturgy. If sacred space should be used for a clear performance of the liturgical drama, what gets in the way or hinders the project? And it is here that the physical war starts. Some people have no idea what a building is telling them.

One of the first things a theatre director does is consider the space a play is to be performed. Those responsible for the design and technical side will have – or, at least, should have – garnered information about the size of the playing area, its relation to the auditorium and how this might enhance or hinder the presentation of the piece. Proper consideration of the area in which a play is to be performed can only assist in achieving the goal of a good

production. It does not take a highly trained critical eye to see where such work has been fruitful. Touring productions can suffer because of the differing environments in which plays are presented. Yet the careful director or promoter will always ensure that adaptations are made to facilitate optimum engagement of the audience with the action and, thereby, the piece.

Such considerations are too often ignored in the church. And it is here where holy war breaks out. There can be a range of causes: ignorance, cherishing a long-held vision, unsuccessfully transferring a presentational style or sheer bloody mindedness. Unfortunately, many worshipping communities are held to ransom by the building.

Wholesale changes may be required. Yet not all congregations, even if they had the will, have the financial resources to turn a building into a proper liturgical space. Richard Giles has written on these matters in his two books, *Repitching the Tent* and *Creating Uncommon Worship*. Sadly, his solution is, quite simply, beyond the reach of many.

In England it appears that the richer a church is, the more successful it is in convincing authorities that some of its arcane rules on changing historical fixtures and layout. The way they want to do things can take little account of the environment they have taken over. They have a house style and it will be used at all costs. Too often this seems to ignore the space they have taken over. Many of the successful — at least in terms of getting their way with the authorities — adaptations seem to lack two things: a sense of history or any sense of liturgical engagement. This can happen in what seems a reverse cycle: a modern building is taken over but the incumbent insists things are done in a "traditional way". This seems to act out some fantasy of historical purity. In both cases, those involved replace one short or ill-sighted view with another.

There is always compromise in these matters. The starting point should always be clarity. What is a church trying to achieve in its services? How will a service in the context of this space be effective in engaging those who gather to take part? What is the appropriate placing of fixtures? What is the relationship of such hardware to the people? What can be done to create a sense of engagement or reverential distance? This requires a knowledge of space,

relationship between those who are to perform within it, and how this can be viewed by the gathered worshipping community.

Many controversial re-orderings stand or fall on consideration of these questions. In some churches there is a growing emphasis on communal emotionalism. This is achieved by an entertainment-styled leading of songs, preaching and feeling. Whatever reservations one may have about this form of service, many re-orderings have been focussed on allowing the elements involved to have due emphasis. It feels like a concert hall. There is a good, clear view of a raised podium on which a band performs. Behind and above the musical ensemble is often a screen on to which are projected images, words, texts as required.

Some churches attempting this style of service fail because they are conducted in spaces which do not reflect their ambitions. Likewise some Eucharistic-based worship suffers because no consideration is given to the setting for the liturgical drama being enacted. Small, informal spaces can be populated by po-faced gentlemen in Victorian robes, doing hospital corner turns because someone, somewhere once read and believed the instructions as shibboleths in an edition of *Ritual Notes*.

The simple fact remains is that most buildings can inform church members about the liturgical vision for those who designed and built them. The questions at issue are these: How far do we share in that vision? Can adaptations be made to either the order of service or the furniture to achieve a closer marriage between our aspirations and the physical environment? What needs to be done to allow us to conduct services with the directness we desire? In short, how can we achieve our aims?

Fit for the purpose

It goes without saying, then, that if there are no aims nothing can be achieved. Many services start and finish as though these questions have never been posed. Indeed, I am often convinced that they have not. It is a sad indictment that the book and bum based learning of much of the leadership of churches ignores such basic aesthetic bodies of knowledge such as architecture.

The same applies to the theatre. I remember a gathering of theatre directors crying into their beers when a new theatre had been built. It had lavish facilities in the foyers, spacious bars,

even addressed the vexed issue of the number of toilets for women patrons. Where it failed, they said, was as a theatre. The relationship between actor and audience was skewed. The stage was large, but there was no depth or adequate wing space. It was effectively a black box which could not be transformed. It was not much better on the other side of the proscenium arch. There were poor sightlines from many seats. The acoustics left much to be desired. The horror continued backstage. The dressing rooms were pokey and even there was insufficient space for the storage of props and costumes. It did, however, look good. The cry went up as it has done before: why on earth did the architect not ask the directors, actors and designers what they needed to do their job?

It is a truism that anyone designing a space for public events needs to understand its purpose. This goes for halls, theatres and churches. It is well and good to hope to provide a space which is adaptable to as many purposes as might be needed. Yet it needs to be remembered that some specialist provision, such as that for theatrical lighting, is complex in planning and construction. There are experts in these fields and they should be consulted.

It is a sad fact that some fit–for–purpose facilities of a former period are just not up to the job for current needs. I do not know of one theatre that insists on using limelight in its productions. It is harsh and dangerous. It served a purpose. It can be read about and studied, but not used. Some theatre stages, especially those flat, dead spaces of the old church hall, are just meant to be ignored. I recall a tour in rural Victoria where the company often put seats for the audience on the stage and performed on the auditorium floor.

I recall visiting a church that had a near–lethal step just behind the altar. The priest had only to take a step back to find himself over the edge to a three–foot drop. It was an accident of history. Priests used to preside from the other side of the altar, eastward facing. With the adoption of more modern liturgical trends, though without a budget to accompany the changes, the altar was simply moved forward and the celebrant moved to the westward side. To gain access there was a small set of wooden steps. These were to one side of the altar. Hence, a backward step led to a drop.

Similar surprises come in new buildings. A vestry in an otherwise beautiful new church in north London has some alarming traps for the young player. If you bend to remove

anything from the vestment chest, you knock your head on a beam that no doubt offers structural support to a higher part of the edifice. Another church of a similarly recent vintage had a raised sanctuary to which those going forward to receive communion had to negotiate one step before kneeling. So many people had forgotten this as they retired from the altar rail that warning signs had to be attached to the rails. This detracted from aesthetic quality of the rebuilding almost as much as the unspeakably ugly statues from Malta.

Good spaces need good planning. A theatre is not a church. But each can learn from the other. If the purpose of performance is clear, if the issues are discussed appropriately and in depth, then an architect will be greatly assisted in designing something fit for purpose. It does assume, however, that those who will use the space will know what they are doing. Sadly, this cannot always be assumed as a given.

I remember missing the entire scene in which Mrs Lovatt is cast into the oven by Sweeney Todd in the eponymous musical at the Royal Opera House. The action was all played upstage and could only be viewed by those sitting in the orchestra stalls. One would have assumed that a director would want this piece of the action seen. That it was not is probably due to fact that the director viewed the dress rehearsals from the best seats in the house. A similarly limited view was presented to anyone sitting in the upper seats of the Apollo Theatre in London in a 2006 production of *Who's Afraid of Virginia Woolf?* The design incorporated a ceiling which rendered any actor upstage into a pair of legs in shoes.

The presentation of liturgical and theatrical drama takes place in a holy space. Those who design it and perform it have a duty to those who will attend. Watching a play or assisting at Holy Communion is, despite the passivity that may be involved, the reason for the performance. To ignore their needs, in the same way to be ignorant of the needs of those involved in the performance, only makes for bad spaces.

Chapter Ten

Pathways to Performance

The staging of a play goes through a series of steps before being put before an audience. Ideally this is a collaboration that involves a range of people in various tasks. At some points along the way there are times to pause and reflect. Once again, there are appropriate points of crossover for those conducting public liturgy in church circles. This chapter will try to explore some of them.

The work before the Work

It is hoped that actors will at least have read the script before the first rehearsal. Doing so can point the way to a number of matters that can or should be addressed before the motivating, blocking and firming external action. Are there aspects of the play that lead to questions? Can these be answered by simple reading around the historical or social context of the drama?

In the case of a large part, for instance Hamlet or King Lear, the director and the actor may have had a number of preliminary meetings, trying to work out a common approach to save unnecessary clashes or misunderstandings later. Tensions between performers and directors can be huge and many of the problems can be avoided if there is a sense of shared ownership in a production. This again can give a sense of common purpose to a project.

Respect is vital. If a director thinks little of actors, as the Victorian Edward Gordon Craig has been accused of, there can be real tensions. According to the Oxford Companion to the Theatre, "His theory of acting has been much criticized as reducing the actor to the status of a puppet working under the instruction of a master–mind 'capable of inventing and rehearsing a play; capable of designing and superintending the construction of both scenery and costume; of writing an necessary music; of inventing such machinery as is needed and the lighting to be used'".[9] This certainly places a huge onus on the master and, not surprisingly, can raise the hackles of those who might fear their creative input has been discounted before the commence of play.

Likewise an actor who thinks directors are either unnecessary or on a kind of ego trip will undermine the hoped for openness to be found in rehearsal. A number of actors, epitomised perhaps most boldly by Peter O'Toole, believe that the director is by and large redundant: actors know what to do and can achieve better results without an "expert" sitting on the outside. Anthony Burgess argued that orchestras did not need conductors: most of the tempi are taken from the first violin anyway and the conductor does little but indulge himself while in front of the performers. Such a view would agree with one of James Roose-Evans's reflections but not the second: "An actor must be as aware of time and timing as a musician is"; "The director is like a conductor. He has to study the score. It is his understanding of the sub-text that will suggest the rhythm, tempo and pitch of a scene." [10]

Others suggest a more open role, more akin to someone inviting, encouraging and distilling the contributions of various workers to combine to a whole. Most directors are somewhere between the two: Oliver Ford Davies's account in *Playing Lear* is encouraged by the openness that his director Jonathan Kent brought to their early meetings, apart from his reservations that a design concept, in which the panelled walls of the theatre started to fall apart as King Lear does so on stage, where he sees a potential clash between the actor's contribution and the coup de théâtre provided by the crumbling edifice around the audience.

The catch-all term for the work that needs to be done in advance is research. This can take many forms: historical facts and figures may be needed to get a factual and political flavour of a period; social trends and fashions need to be understood. It can also alert a performer to aspects of the emotional life that may be a challenge in performance. If someone is playing a murderer or a character whose emotional make up is far from how the individual sees themselves, a simple note in the margin of the text can lead to productive triggers:

- is there something in my life that parallels the feelings expressed here?
- have I read something that gives a flavour of this?
- do I know a person who has been through this situation?
- are there places like the one in the text I can visit?

In his extremely practical book, *Directing A Play*, James Roose-Evans points to the overarching view that a director can bring to

a production. The chapter titles themselves give the flavour of the breadth of a director's concerns: Planning a production; Blocking a production; The director and the actor; The actor and movement; The actor and improvisation; Working with props; The director and the stage management; Lighting and sound effects; The last few days; The director as magpie; Reflections. One of Roose-Evans's constant themes is about the purpose of a play. It is what is done to bring it all together that matters. Too much emphasis on one element can be distracting; if a director does not like a play, it is better to select another one rather than try to bend one to a concept that does not spring from the text.

Planning the production

Those preparing for public liturgy can follow many of these directions. Planning a service can go from the simple to the complex; a plain said service of Holy Communion can involve little more than selection between various options within a formalised set text. Much of what takes place is known, though it is worth regularly challenging that idea, and repeating what is already habitual.

Creative liturgies, for want of a better term, need a more open approach. What is the service trying to do? Who will be involved and who is it for? Are there appropriate tasks that can be shared or is it best to be seen as a solo? What is the balance between set texts, music, silence and prayer? Consideration needs to be given to composition and performance. Too much emphasis on one element can skew the balance.

People taking part in such services come with no previous encounter. It is like the audience of a new play. Unlike a classic, which may have had hundreds of performances, so much so that critics seem to concentrate on comparing this production to others they have seen, a new play has an element of surprise. The story is unknown, the characters are new and the drama that unfolds is fresh. A friend of mine recently warned me that he was doubtful he would accompany me to another production of *King Lear*. "We know he is a fool and will treat his daughters badly in the first act. He will get his comeuppance and we know how it will end."

An important aspect of any production or liturgy is how it fits the space in which it takes place. This can be done effectively, using the space to enhance the performance, or disastrously. It can be

intentional or the product of ignorance, insisting on a certain form that is at odds with the environment in which it is taking place. Anyone who has performed or been in the audience at an open air performance on a cold, windy day will know that setting can add its own flavour to what might have been a perfect production. (A fuller consideration of this can be found in the chapter, The Holy Space.)

Having selected what is to take place, it is then important to see if the performance works.

Making the move

Actors can often find the move from rehearsal room to theatre a challenging experience. The intimate relationships built up can fracture in the move to the theatre. So also can some of the conceits of production. Charles Laughton famously played the storm on the heath as something that was inside King Lear's head. As such, he argued the famous speech did not need sound effects or other enhancing stage management in performance.

You cataracts and hurricanoes, spout
Till you have drenched our steeples, drowned the cocks!
You sulphurous and thought–executing fires,
Vaunt–couriers to oak–cleaving thunderbolts,
Singe my white head! And thou, all–shaking thunder,
Strike flat the thick rotundity o' the world!
Crack nature's molds, all germens spill at once
That make ingrateful man!

This may have been electrifying in the rehearsal room but it was generally considered a failure when it got to be presented in front of an audience.

A priest may not be doing anything as complex as King Lear – though many would argue they are doing something much more complex. Whatever the attitude to the material, it is important that priests know the text, if not off by heart, or at least its shape. That way the words and actions can be lifted to a suitable height. There is no shame in rehearsing these things. If a priest is going to a church they have never been in before, they should bring the shape with them but try to adapt it to the place, vessels and people involved. Context is all.

That is what the following chapters will seek to address.

Chapter Eleven

When Speaking In Church!

Or More Generally
Things to Bear in Mind
Before Opening One's Mouth in Public

As you can see from the title of this chapter, this is has a particular target audience. It also comes from a precise reference point. Despite what looks like an attempt to imitate a Victorian playbill, I hope what follows is more or less what it says on the tin (or chapter title).

I penned these reflections soon after returning to London and I was asked if I might have something to offer other priests as a result of my sabbatical. It is for that reason that this chapter is primarily aimed at those who want to do things better in church services. I based what I had to say on the advice that comes out of the mouth of the Prince of Denmark, Hamlet, when he speaks to the Player King.

If you think this is not something for you, then I invite you to skip what follows. But then, Hamlet's advice was for actors. As such, they do get a mention, but mainly in the service of the church service.

It is a commonplace, and one that is true in the saying, that liturgy should be prepared for. Such preparation is best done prayerfully. Many different observances can, and should be, maintained: silence, formal prayers, vesting rituals to name but three. Unfortunately, the successful observation of these is rare. Too often the leader of the sanctuary party is distracted by concerns about others involved in carrying out liturgy. Are the readers there? Have all the servers turned up? Are the musicians in place? Who will carry out what ceremonial tasks where and when?

These are even more mundane matters that apply outside the sanctuary. Has the urn been turned on? Is there enough coffee? Has anyone remembered to buy the milk? Such outward looking, though arguably hardly missionary, concerns can have disastrous effects on the entire project of worship.

This is not to suggest it is only the clergy who distract themselves. Often similar worries are being enacted by other people in another part of the building. Has the person who is to give out the hymnbooks or service sheets turned up on time? Does the person who operates the sound system know that a shouter will be preaching? Has the special car–parking place been reserved for the bishop? Who is doing the coffee? Has the urn been turned on? Has anyone remembered to buy the milk? In some churches there is one other element of panic: will the vicar be coming down here to check on us?

Who looks after what?

There is a lesson to be gained from what happens in the theatre. It relates to delegation and responsibility. You would not expect the box office staff and catering team in a theatre to be worried about the state of an actor's preparation. Of course, it is important that the performers are up to the task, but those who work in the front of house have their own concerns. These can range from the stock of programmes, ice creams, the amount of tonic for the gin, the cash float. It is the liaison between the backstage and front of house that is important only when something on either side is wrong.

Clergy are often their own worst enemies. Sometimes they want to dominate in the two spheres — the narthex and the vestry. Ultimately this can put off any proper preparation for the conduct of worship. It also undercuts any delegation that has been given to others to take appropriate responsibility for the tasks they have in hand. It also distracts them from devoting themselves prayerfully for what they are about to do with and on behalf of the assembly — the special task of presiding and preaching. Something can be drawn from the actor here. It would perhaps be better to concentrate on what they are going to do in the service and leave the other aspects to the welcoming team.

What happens in the vestry and dressing room is crucial to performance. Not that all actors are that easy to get along with in the privacy of a dressing room. It can be unnerving just encountering others. What personal baggage has been brought in? Is it appropriate that it is shared or showered on colleagues? Are warm up exercises helpful to one individual, but possibly unsettling to those in the vicinity?

66

There can also be a disturbing effect on fellow performers when there is a sudden termination of social chat. Up to a certain point — one that has not been agreed with fellow performers — it has seemed relaxed and social. Some like to joke and make light of the drama that is to be enacted. Others assume an aura that would not be lost in a funeral director's. Whatever it is, it can briskly come to an end. An inner switch flicks and the actor becomes the character. (Some may say that it does not matter what happens before a performance. Actors are not judged by what they do in the dressing room.)

The similarity I point to is a simple one: how one treats colleagues in private can affect the way they respond to you in public. For one actor, this may be sauce of the character goose. For another, it can undermine their personal confidence.

Similar dramas are played out in vestries. "Be still and know that I am God"? A chance would be a fine thing. Not wanting to seem pious or standoffish, clergy can engage colleagues and acolytes in conversation, in light and laughter peppered banter, that does little to centre themselves, let alone those who will serve with them in other roles, for doing what Jesus ordered his followers: to celebrate his presence in the form of bread and wine.

Some clergy's behaviour is bizarre, to say the least. There must be an inbuilt alarm clock in some of them which dispels camaraderie. As if commanding suddenly threatening demons, they will look solemn and command, "Let us pray". But the damage has already been done. The young server will wonder how the animated football enthusiast, who up to that moment was sharing details of yesterday's match, has been swallowed by a scowling ascetic.

It is vital that all those involved in the conduct of public worship prepare themselves adequately. It is too late to do this in a few minutes before a service starts. It needs to be learned, marked, and inwardly digested, so that it becomes a natural part of celebration. It needs prayerful recollection. That needs time. Others rely on different techniques. Many have their own peculiar methods when they find time is not available: some recall stern training incumbents; others will think of a saint.

This behaviour is focussed on preliminaries. It would be better to focus on what is actually being prepared for. The preparations for services should all be in place, like a dressed set, so that the time before it can be creative and calming. Books should be in the right place, marked for readers who will have ensured that all is as it should be. Vessels and other incidental necessities will have been set in place. This should free all involved for the service itself. It is the same with an actor. Arrive in good time; check your costume and your props. Make sure everything that you need is where you want it or it needs to be. Then you can avoid panic later.

When preparing to speak in church or conduct a service, we can take solid advice from one of the theatre's great characters. Hamlet speaks to the Player King in his eponymous play:

Speak the speech, I pray you, as I pronounced it to you, trippingly on the tongue; but if you mouth it, as many of your players do, I had as lief the town crier spoke my lines. Nor do not saw the air too much with your hand, thus; but use all gently. For in the very torrent, tempest, and, as I may say, whirlwind of your passion, you must acquire and beget a temperance that may give it smoothness. O, it offends me to the soul to hear a robustious, periwig–pated fellow tear a passion to tatters, to very rags, to split the ears of the groundlings, who, for the most part, are capable of nothing but inexplicable dumb–shows and noise. I would have such a fellow whipped for o'erdoing Termagant; it out–herods Herod. Pray you, avoid it. [11]

This sort of performance is usually reserved for those sitting in the nave. The yelling vicar wanting to be heard, polished vowels and impossibly clipped consonants carrying to the very back row where, invariably, the majority of the congregation will have taken up residence. But there are many opportunities for the rampaging leader of worship: they may have to read; they can take over the prayers of the people; they might even ascend the pulpit. Whatever context, it is fraught with danger. Some have an enviable knack of hitting the wrong word in a sentence. I was once called to order by a fellow worshipper when at a service my jaw

had dropped open. I had not thought it possible to emphasise so many weak words at the expense of the thrust of verbiage in one prayer. But it was. Indeed, the speaker could have been rehearsing such ineptitude for years. It was that accomplished.

Yet Hamlet's advice is for what happens in performance. It is the preliminary to the equivalent of a director's dressing room chat: "You have done the work. Now just relax and enjoy it!" He is telling the players, through the King, what they should look out for.

It has already been noted that it is before arrival in the vestry (the equivalent of the dressing room) and the procession (first entrance) that many things go wrong. Having already failed to establish a prayerful recollection, the fracture becomes compound. I recall being in a vestry with a priest who called us to prayer. Her face screwed up into a ball, such that all I could think of was a baby pooing its nappy. Her voice moved from the realms of the reassuringly normal to a scary breathy earnestness. Each invocation was separated by a pause that had meaning, I am sure, to her. But for the rest of us it was a mystery. When a word needed a particular emphasis the eyes were screwed up even tighter and the head would bounce in manner of a Gerry Anderson puppet coming to a halt. It was riveting. It was fascinating. And it was totally inappropriate to the prayerful contemplation of God before public worship.

> ...Be not too tame neither, but let your own discretion be your tutor. Suit the action to the word, the word to the action; with this special observance that you o'erstep not the modesty of nature. For anything so overdone is from the purpose of playing, whose end, both at the first and now, was and is, to hold, as 'twere, the mirror up to nature; to show virtue her own feature, scorn her own image, and the very age and body of the time his form and pressure. Now, this overdone, or come tardy off, though it make the unskilful laugh, cannot but make the judicious grieve; the censure of the which one must, in your allowance, o'erweigh a whole theatre of others. O, there be players that I have seen play – and heard others praise, and that highly – not to speak it profanely, that, neither having the accent of Christians, nor the gait of Christian, pagan, nor man, have so strutted and bellowed that I have thought some of nature's journeymen had made them, and not made them well, they imitated humanity so abominably. [12]

These observations could be continued throughout other aspects of the liturgy. I have seen priests in procession as though they were strolling down the promenade on the seashore, expecting someone else to admire their finery as they obviously did themselves. Or those whose posturing is a more formal decrepitude. They become bent over as though living with a seemingly terminal osteoporosis. They wear robes that look like they have been slept in overnight. These are, however, mere preliminaries. Hamlet's advice is about fitting actions to words. So, in the context of the dreary Dane's words to the flamboyant Player King, one should perhaps not be too critical of those who are making fools of themselves while remaining mute.

The voice is a physical instrument. It is no surprise that a clerical training programme that makes no allowances for so many practical aspects of the public functions of ordained ministry does not provide work here. An actor in training does daily classes and drills to prepare for the physical work of speaking in public. Overuse, however well intentioned, of microphones and public address systems, have made many actors and priests lazy. They cannot be heard at the back of a theatre or a church if the mechanical devices fail. They will almost certainly be inaudible for those attending an outdoor venue or a graveside service next to a busy road.

Some priests have horror stories of the retired actor rolled out to teach would be clergy how to be heard. Good advice is simple. One of the best small books I have seen on these matters was designed for teachers. With the apposite title *Can You Hear Me At The Back?*, it contains many useful tips. But, as brevity is always a recommendation in itself, the author, Caroline Cornish, offers six words of advice: stand up; breathe in; speak out.[13] Perhaps the clerical version should be the same.

Chapter Twelve

Lifting Holy Hands

The hands are a sort of feet, which serve us in our passage towards Heaven, curiously distinguished into joints and fingers, and fit to be applied to any thing which reason can imagine or desire. – Thomas Traherne

Parts of our bodies are often taken for granted until something goes wrong. Our ears do not bother us until our hearing begins to diminish. Our eyes are perfectly acceptable until we find ourselves squinting to make out some small print in front of us. Our skin is an unwitting covering to us until a rash develops.

Some of the busiest parts of most people's bodies are their hands. When they go wrong, whole areas of life can seem compromised. A paper cut on a finger can conspire to make a person's workaday life uncomfortable. Each tap on the computer keyboard sends a sharp reminder of pain that the skin surface has been ruptured. A split nail can distract attention from someone listening to a client. Arthritic wrists can channel thoughts from all else except the pain. In many ways, these physical diversions are essentially personal. We can keep our discomfort to ourselves and attempt to get along with the purpose in hand.

Hands, however, can also be distracting and diverting. Much is made of the hand gestures between differing cultures. The tourist is warned not to point with the finger in Malaysia, as such a gesture is considered offensive. A gentle gesture of the open hand toward an object is sufficient, and polite, indication. The extension of the arm, which leads to a firm handshake in one culture, may be inappropriate in another. An Australian businesswoman would not be offended by such a gesture by a man, but an Orthodox Jewish woman would not welcome the same manual overture. A hand to a part of the body, for instance a chin or the forehead, can cause great affront in some parts of Europe. On the Indian sub-continent a visitor needs to take into account the distinction in the use of different hands: the right is used for eating and contact with others, the left is used for baser uses, especially in the toilet. Winston Churchill's victory sign, inverted and given an upward dynamic movement, is widely recognised as a confronting insult.

Reading hands

Watching others' hands from a distance can indicate when events are unfolding as expected or if something is going wrong, even when the dialogue is indistinct. At a building site an architect and builder are surveying the work in progress. The designer steps back, folds her arms and turns her head up and down to ensure intentions have been achieved. A nod towards the builder and, almost inevitably, the arm will be extended into a pointed finger to an aspect of the project under review. If a plan is being held the digit will move from the reality to the plan to the drawn concept.

A driver pulls up after a minor collision between cars. Much can be learned from hands as to the drivers' emotional state. A door is thrust open and hands are splayed away from the body – "it wasn't my fault!" The repeated wringing of hands can alert the spectator to nervousness in the encounter that is to follow. Fists can be a signal of frustration or potential anger. The rubbing of a part of the neck tells the viewer of an injury.

Much is made of gestures that reveal a "type": the fussy housewife, so wonderfully portrayed by Patricia Routledge in the character of Hyacinth Bucket; the ever-busy hands of the simpering drag queen; the reined-in activity of a sentry at his post; the effusive gestures of expansive saleswoman; the sustained control of a Tai Chi instructor.

Given that so much can be and is revealed by our hands, it is no surprise that both priests and actors should give attention to them. Considered use of them can assist the wider purpose of both theatrical and sacred performance. Ill-timed, unthought-out and sloppy gestures can distract or even destroy the import of such work.

Having noted the features of emotional state and "type", an actor will be wary of using what might be considered a cliché. Actors often avoid stereotypes, even if they have been clearly called for by a writer. Entertainment can be gained by consulting manuals of gestures designed for actors of former times. One, *Elocution* by T. R. Walton Pearson, shows the appropriate hand gestures, and the requisite facial and body attitudes, that can show anger, resolution, mirth, love and obstinacy. A modern performer, unless doing a piece portraying an earlier form of histrionics, would

eschew such detailed instruction. Such codification of gesture is still required in some areas of the performing arts: Kabuki and Noh theatre in Japan depend on them. It is still used to a limited extent in both western classical ballet and eastern dance.

What do I do with my hands?

Developments in film acting in the twentieth century led to what many claim is a natural style of performance. The observation is arguable. Some American actors of the early 2000s seem incapable of keeping their hands still unless they are taking the role of a corpse. I recall with wonder and amusement the scene when Stanley Kowalski, played by Marlon Brando, meets Blanche DuBois in *A Streetcar Named Desire*. Having entered the house and removed his jacket, Brando is seen scratching his chest as he moves across the room. He is then filmed from behind as he passes Vivien Leigh's Blanche. He is scratching his back.

For all that, an actor needs to know when and how to use one's hands. For much of the time the instinctual gesture is sufficient. There are times, however, that particular attention needs to be given hands. Inattention or carelessness with the hands can divert the focus of the audience away from the plot or theme of the play. Michael Green's Coarse Acting books provide numerous humorous examples. These examples reveal something of the uncomfortable amateur.

Actors can become aware of their hands as part of the realisation that they have not found their way into their roles. Not knowing what to do with one's hands is a symptom of something larger: the actor has not found a secure way into the character she is assuming. The mirthful mockeries of Michael Green are evidence that we can recognise the image of the uncomfortable would–be performer strutting the stage.

A good director can assist the journey of an actor in these sometimes uncertain waters. Focussing on the text, the clarity of its exposition, the actions and situations, can lead to a physical relaxation. The actor sees his part with clarity. The mind influences the body and the discomfort is removed. Activity is married to intention.

Any gesture of the hands can add to or detract from what is being conveyed in a scene. By way of example, imagine you are

playing the scene of a sheriff in a western. The posse has gathered and you have given them the rundown of their quarry, having warned that the bad guy is desperate and will not give up easily. You have two more things to do: deliver the last line "Let's go" and cock your rifle ready for action. There is an enormous difference of intent and effect by where you choose to load the first bullet into the barrel. Before gives an indication of caution and perhaps nervousness. During can indicate a sense of urgency, not wanting to hang around while there is a job to done. After can intimate a calm resolve to be ready. Even these variations can be extended. The illustration shows that the cynic who says acting is just saying a few lines and hitting a few marks intentionally underestimates the range of possibilities within a role.

It is hard to find better advice to actors about the appropriateness of their gestures than Hamlet's advice to the Player King. "… do not saw the air too much with your hand, thus; but use all gently." "Suit the action to the word, the word to the action." The prince's instructions are hard to beat. (see the chapter *When Speaking in Church*)

A priest should have similar regard to the effect of gesture. I have been entertained and infuriated by clergy whose hands seem to be more akin to Australian blowflies near excrement rather than those lifted holy members referred to by St Paul. There are many examples to draw from: the priest who cleaned his ears, picked his nose, bringing the results of such excavation on a pointed finger to his eyes for an inspection during the singing of the Gloria; the hands which alarmingly headed toward the sky, as though the result of a string being pulled on a doll, at the invitation to the congregation to share the Peace; the riveting curling and uncurling fingers on one hand and then the other during the recitation of the Eucharistic prayer; the pushing up of the glasses on the crown of the nose as the right hand made its upward way to give the Blessing. The defence may be offered that the offenders were unaware of the activity of their hands. The prosecution would be forced to respond, "Well, they should be."

Manual acts in the celebration of Holy Communion can lead to fierce discussions among clergy of a certain persuasion. The choice of the gesture, the manner of its execution, the height of hands at any given point, what actions take at what place. To a certain extent, some forms of liturgy help the priest. *The Book of Common Prayer*, like the Roman Catholic missal, has instructions of what should happen when. An example of this is the timing of the fraction, when the bread is broken. Annotations appear in the body of the text of the words of institution to ensure that action follows utterance.

There is an extensive range of optional extras: elevations, hands moving over vessels to indicate the calling of the Holy Spirit, the invitation to the gathered community to receive. There is the simple and the fussy. The Benedictine nuns at West Malling Abbey were revolutionary in their time by forming a circle round the altar while the Eucharistic prayer was said by the priest, who had strict instructions to keep his hands in the *orans* position, and not to use any other manual acts. Richard Giles, in his book *Creating Uncommon Worship*, advocates a similar posture should be adopted by the entire assembly. He also argues strongly against any other actions.

There is much to select from: the repeated fivefold crossing, as favoured by 1960s students at Mirfield theological college; the wiping of thumb and forefinger along the edge of the corporal before picking up the priest's wafer; the holding of the thumbs to the first fingers on each hand after reciting the words of institution to indicate that the host and wine are now the body and blood of Christ and avoiding contact with anything other than those sacred elements. Quite simply, the hands can point to a broader intellectual canvas. The very manner of taking and elevating the elements at, during or after consecration, can reveal one's attitude to what is going on, even a person's theological understanding.

One enticing argument is to enquire as to the basis of a manual act. In most cases, in my experience, priests simply do not know why they do one gesture over another. Ignorance may be blissful but is also contagious. For some it was enough that this was the way they were brought up. Fr Soandso did it like that and that is good enough. There can be longwinded justifications or simple

admissions that, like the Zen process of the mass, they are awaiting enlightenment to dawn. The worst justification is "This is my way of doing it". The response is, "Be that as it may, is serving the purpose of the greater good?"

There can be a simple process that can aid all. Priests should ask themselves first if they are aware of what their hands are doing. If they are not, they should get someone else to monitor them in action. Videos are most instructive. Many people are unaware of how busy their bodies can be in what they believe to be simple conduct of gestures. Having witnessed their excesses or shortcomings the questions are easy:

- is this gesture necessary?
- do I know why I do this?
- what is its purpose? For whom?
- should I abandon it?
- is my execution of it good/bad/indifferent?
- what might I do to improve it?

This process can be repeated for each action.

For those who routinely use manual acts and gestures an occasional audit is responsible. Bad habits creep in and, when one works alone, they can go unchecked and become worse. An actor in a long running play expects a director, or at least an assistant, to monitor the show and offer "notes", the corrective instructions that are thought helpful to return performance to the agreed acceptable standard. Despite carping by bishops and others about the regrettable quality of worship in churches, I am unaware of any roving officer who has been appointed in the church with the responsibility of monitoring it. (The same is regretfully true of preaching.)

It is particularly important that there is at least a nod towards agreement when more than one person's hands are being used during liturgy. Inviting the assembly to mirror the actions of the president, as Richard Giles suggests in *Creating Uncommon Worship*, is fine only if priests know what they are doing. If they do not, the variations can become uncontrollable.

Such advice holds good among the clergy. Concelebrating does not imply uniform gesture – though there is a case for it – but an essay at restraint so that no one priest's actions distract those who have also gathered to assist at the mass. The general rule, a variant of the Peter McGeary formula quoted in the next chapter, worth remembering is simple: symmetry is holier than pedantry. If a priest invites another to concelebrate, it is a courtesy to enquire if the guest has any strong views on the matter. It is also worth providing some steerage in the matter – a concelebrant's *rituale* with rubrics is no bad thing.

Some writers, from Fortescue and O'Connell to the more recent Dennis Michno, offer detailed advice that ranges in essence from command to suggestion. I believe a couple basic rules can be applied. Be aware of what your hands are doing. If you are not, ask someone to monitor this for you. Hands should be kept together when praying with others or extended into the *orans* position when praying on behalf or for others. It is best to match height and hand shape while doing this. The saying of Jesus that one hand should not know what the other is doing refers to the giving of alms, not making manual acts during liturgy. My mind still reels when I recall my reaction to watching a one handed celebration of Holy Communion while the second was clutching a microphone.

If a actor or priest's hands are not distracting those who are watching or gathered to share in the celebration of Christ among them in the form of bread and wine, it can be assumed that all is well. If they are distracting, something is going wrong. Drastic measures are enticing, though should be met with caution. Again, one should be careful on how one interprets such renderings of the words of Jesus in the fifth chapter of Matthew when he says that if a hand offends you should cut it off.

Chapter Thirteen

Developing The Third Eye – Outside Looking In

One of the most revered and reviled people in theatreland is the critic. To a cynical eye the reverence can be construed as a mere psychological payback for praise; that is to say, people who work in the public eye cannot help but love critics when they say nice things about them. The opposite is worked in a similar vein: no–one can take seriously or commend the critic who has put the boot into a personal performance or work. Harry Enfield caught these contradictory tendencies in one vignette of his Bores series, enhanced with cartoon drawings by Michael Heath, in the satirical magazine *Private Eye* some years ago, where The Actor in turn curses and praises the same critic, Michael Billington of The Guardian, for having condemned and lauded separate performances. That Billington had done so added credence to the actor's arguments against the importance of the critic and in favour for his seemingly inflated self–esteem.

A critic, at least in the traditional sense of the word, is someone aligned with, but not beholden to - or should not be — the matter under the cultural microscope. There is a strong case for some degree of separation between the artistic manufacturer and the consumer. Those on the receiving end do not need or want to know many of the finer points of preparation and process that have led to a product. After all, an element of performance should be entertainment. It has been said that good acting should look easy; if it appears strained or difficult, it undercuts its communication. People want to admire the vehicle in motion; they do not want to look at the working parts of the engine.

Having said that, there are times when a basic knowledge of the arts involved is essential. Few chefs are employed as restaurant critics. This is usually left to a journalist with a penchant for, or a paunch from, good dining. A wine critic, on the other hand, can often display a dazzling knowledge of grape types, how the growth of the fruit is affected by climate, the ageing process in what kind of vat, as well as the bizarre similes that can arouse derision among those who are not among the cognoscenti. The music critic, at least in the field of the classics, is similarly expected

to have more than a passing acquaintance with the works, and perhaps antecedent performances, they will put under scrutiny when they are presented.

This is arguably taken further in the world of literature. It is common for a fellow writer, indeed sometimes a friend or colleague, to be asked to review another author's new book. *Private Eye*, again, captures this ambivalent calling well when it gathers what could be construed as an intellectual bran tub for authors engaged in mutual backslapping in Christmas and summer reading recommendations. The inherent charge would seem to be that friends reward each other with favourable reviews of their latest wordplay.

The quality of criticism is often strained. There is a tension between someone sitting in judgment on another who has been through an extended period of rehearsal and risk. Nearly every performer has a tale of an associate, friend or loved one making the mistake of honestly airing their opinion about a work too soon: emotions are raw, nerves are often jangled and hopes are still high. Neither is a studied silence any comfort: performers know that quiet is often masking a seething jungle of condemnatory phrases. Attempts to assuage the situation with a neutral offering is likewise potentially catastrophic. If someone responds with "It was interesting" when a member of a creative team asks an audience member what they thought of a production, the inquisitor will more than likely assume that it is masking another statement, "I loathed it."

Sometimes the nature of the relationship can affect the interchange. I know from personal experience that this is can be an emotional minefield. My wife, Adey Grummet, was in a show about which she was, all through the preparatory period, save for the interminable boredom that is often part of the extended technical rehearsal, eagerly enthusiastic. When I voiced my negative view of the piece at a preview (and I could well have found less abrasive ways to formulate my wine enhanced criticisms), I had strayed into the waters infused with emotion and personal esteem. How I envied the tutor of her musicals writing class his bold summation of the same production: "Honey, I haven't hated anything so much in ages!" Adey laughed when he said this.

The mighty power of the pen

Status can also feed into this. The theatre critic is often accused of wielding great power. In some quarters they can still have popular authority to make or break the business of a show. This is perhaps most evident in the names of the parades that capture commercial theatre – Shaftesbury Avenue and Broadway. A number of shows owe their artistic or financial future to the decisive review, the one that held back or turned the tide of negative feedback about a production. Success or failure can follow the opinions of these key arbiters. This was said of Frank Rich, not so flatteringly known as the Butcher of Broadway. It was said that if he did not like your show, it was dead. Rich's role in the drama of theatre politics had social ramifications. It has been reported that his arrival at a theatrical reception would be greeted by a mass walkout of members from the acting profession. Others, such as Clive Barnes, were held in a mixture of fear and admiration. It is generally considered a wonder that Laurence Olivier accepted the move of Kenneth Tynan from his notepad in the stalls to the engine room of dramaturgy when he appointed him Literary Manager of the nascent National Theatre in London in 1963. Tynan had the confidence and front to nominate himself for the post.

There are producers of a number of shows who report that one influential review has turned the tide of business for good or ill. Some of these judgments that swim against the contemporary tide only gain power in retrospect. Theatre history records the legendary Harold Hobson standing out against his counterparts to stick up for Harold Pinter's talent in 1958. He first did this when he saw *The Birthday Party* at the Lyric Hammersmith — he had missed the opening night and attended a midweek matinee amid a tiny audience — though it came too late. The play week closed within a week. He again lauded Pinter's talents in a double bill of his short plays, *The Room* and *The Dumb Waiter* at the Hampstead Theatre Club two years later. It has been widely reported that Pinter threatened to abandon playwrighting completely after the experience of *The Birthday Party*.

The director James Roose-Evans recalls in his memoirs, *Opening Doors and Windows,* the importance of Hobson as a visionary critic for the fledgling years of Harold Pinter. Hobson pointed to a performance of the double bill, wondering why Pinter's

plays were not making it to the West End. Though Roose–Evans himself says how Hobson called for another Hampstead Theatre production, Colin Spencer's *The Ballad of the False Barman,* to be closed because of man baring his buttocks in the show.

The heartening tale of Hobson's intervention has more than its counterweight where negative reviews from similarly influential quarters have virtually killed off the chances of a play or musical, some of which have vanished as little more than a footnote in theatrical history. In 2010 a production of *The Fantasticks,* a simple musical that had had a run on Broadway that had set several box office records, was met with such universal stinkers that it was impossible for the backers to set their face against the tide of negativity. The cast of the West End production was given notice that the show was to close two days after it opened.

For all the mixed elements and dangers of criticism, I believe there is something to be gained from the theatre and the church drawing from each other in this field. This could effectively lead to a sharpening of each one's critical faculties. It should come with a variation of the health warning already mentioned: not all criticism is either comfortable or, more worryingly, that well informed. This is particularly so in the age of blogs and online forums.

What is important to the critic's task is an understanding of the amalgam of solitariness and collaboration that eventuates in what is seen or heard on stage or screen. Too often a critic has an overdeveloped sense of one aspect of the process at the expense of others. Some reviews are so focussed on the text, or even the writer's knowledge of a classic, that other equally important elements – design, lighting, performances and direction – seem to be sidelined. On the other hand, the reviewer might be so enamoured with a single actor's performance, usually the lead's, that no other aspect of the production – the other performers, the design, the direction, even the script – is mentioned. Worse still for a new production are the critics who use the public forum as a display of their accumulated experiences of other productions of the same play.

This, of course, pertains to the external assessing eye of criticism. It is, as can be seen, not always a comfortable or easy relationship between those who have put a performance together and those

who sit in judgment on it. The Australian musical comedian, Tim Minchin, once penned a song threatening violence and wishing other catastrophes against one member of the critical fraternity for a negative review he received in The Guardian for a performance at the Edinburgh Fringe in 2005. Much of its dark humour was heightened by the fact that he went as far as to name the critic, Phil Daoust. Any assessment, whether good or ill, does, however, give substance to the production. It has been taken note of.

The bland leading the bland

Much of this kind of criticism is sadly lacking in church. Perhaps the most common feedback to those responsible for liturgy is the doorstep comment of "Lovely service, vicar", or the condemningly bland, "Nice sermon". Those who lead public worship or regularly preach could well do with structured and informed critical feedback. This could – and indeed, probably should – be helpful in maintaining and raising standards in these fields. It would minimise the exasperation expressed by one English bishop, David Stancliffe, when he was Bishop of Salisbury, saying the gap between theatre and church was growing.

In November 2003 the Church Times reported Stancliffe as saying, "In an age when the standards of public performance are so high, how do worshippers manage to keep on going to church faithfully when the way worship is prepared and offered is often so dire; when it is frequently confused with entertainment, and when it is led by those who apparently have no idea what they are doing or professional competence in doing it?"

The report said Bishop Stancliffe claimed that he was not being critical of any specific tradition. He was quoted as saying that there were many "right and wrong ways of how to do worship" in all traditions — from the Charismatic to the Catholic.

"Things can be terrible or really splendid in all these traditions, but worship must take people along with a basic shape that goes somewhere. It should not leave people vaguely entertained at each stage," he went on to say.

This gap in knowledge of how what one does in church is perceived is alarming. The roots of it are arguably simple: there is no regular or authorised external critic of public worship. There is one unofficial project that can cast a light on what is done in

church. The Ship of Fools website, http://www.ship-of-fools.com/mystery, maintains an occasional watching brief on what is offered to God in churches around the world.

A theologically educated journalist, Simon Jenkins, who coordinates a team of volunteers who visit churches in much the same way as mystery shoppers do large retail organisations, oversees the project. They join regular members of the church with a view of the outsider. Their participation in worship is full, or should be, and they leave a tell tale card in the collection which reads: "You have been blessed by a visit from the Mystery Worshipper; Read about your church soon on ShipofFools.com". The card carries a picture of a masked man bearing a strong resemblance to the Lone Ranger, who in turn holds the said card.

The organisers give clear guidance as to what is involved for those who might want to undertake the task:

Observation – If you have an eye for detail, then you'll be able to write a Mystery Worship report that people will enjoy reading. It's capturing the incidental details that helps bring our reports to life: the limp handshake from the minister at the door; the shade of shocking pink that decorates the ceiling; the moment during communion which makes your spine tingle.

Objectivity – We have no hidden agenda. The members of our team come from a variety of different faith traditions, and their reports vary from the glowingly positive to the gloweringly negative. What we ideally look for are honest, searching and (above all) amusing reports which are critically aware of the good and bad aspects of modern worship.

Nerve – Visiting a church as a Mystery Worshipper can sometimes be nerve-wracking. As part of the mystique of the feature, we ask all our Mystery Worshippers to put a calling card into the plate or bag during the collection. This lets the church know that they have been visited, and it also gives them the Ship of Fools web address so that they can read about themselves.

Those who offer themselves for this pseudonymous work agree to a set of standards and frame their reviews in the context of a set number of descriptions and questions. First up is the name of the church, the denomination, followed by descriptions of the church and its neighbourhood. Then follow a naming of the "cast"

and the date and time of the service. The reviewer then responds to the set list:

- what was the name of the service?
- how full was the building?
- did anyone welcome you personally?
- was your pew comfortable?
- How would you describe the pre-service atmosphere?
- What were the exact opening words of the service?
- What books did the congregation use during the service?
- What musical instruments were played?
- Did anything distract you?
- Was the worship stiff-upper-lip, happy-clappy, or what?
- Exactly how long was the sermon?
- On a scale of 1–10, how good was the preacher?
- In a nutshell, what was the sermon about?
- Which part of the service was like being in heaven?
- And which part was like being in... er... the other place?
- What happened when you hung around after the service looking lost?
- How would you describe the after-service coffee?
- How would you feel about making this church your regular (where 10 = ecstatic, 0 = terminal)?
- Did the service make you feel glad to be a Christian?
- What one thing will you remember about all this in seven days' time?

Responses can be couched in the style of the reviewer. Simon Jenkins says the coordinating team is keen to weed out those who want to be either scurrilous or needlessly vicious. However, he does believe that those who are responsible for shabby, ill-prepared worship need to be aware of it. Awareness is the first step on a road to improvement.

I have undertaken some informal research on this. Unless one is reviewed by the Mystery Worshipper, church leaders are highly unlikely to have been given substantial, structured feedback on what happens in the churches they serve. This, somewhat alarmingly, is true even of churches that have worship committees.

This not to say that there are not many books, resources or opinions about liturgy. Peter McGeary, an Anglican priest based in the east end of London, has promulgated one general rule that deserves wider currency: when in the sanctuary, symmetry is more important than pedantry. In a review for the Church Times in August 2010 of Andrew Burnham's book, *Heaven and Earth in Little Space: The re-enchantment of liturgy*, McGeary wrote, "It is good to have a book that says things that — for this reviewer at least — seem obvious, but which need saying, nevertheless: worship is important, it needs care, it needs to be the very best that we can offer, and it is directed to God and not to ourselves.

"I have said before in these columns that one of most important liturgical rules was given to us 25 years ago by the pop group Bananarama: 'it ain't what you do, it's the way that you do it.' Perhaps if that text were placed on every church vestry wall, we might indeed go some way to maintaining or recovering that sense of the sacred which Andrew Burnham rightly feels is missing from so much of what we do in church today."

There are a number of books which seek to equip clergy and others with ways to improve skills and offer warnings on pitfalls in public worship. I have long advocated that every new deacon on ordination should be issued with a copy of *A Priest's Handbook* by Dennis G. Michno. Having said that, it should come with a health warning: all instruction manuals in this field mix experience with opinion. They cannot be accepted without questioning. This advice holds for two other diversely valuable books, *Creating Uncommon Worship* by Richard Giles and *How Not to Say Mass* by the American Jesuit Dennis C. Smolarski.

The role of music in church and theatre is vital. It can be used in uplifting, enhancing and focussing ways. It can also be devastating. A well-ordered presentation on the stage or in church can be destroyed by badly chosen, ill-played and ineptly performed material. For the stage the role of the musical director, especially in music theatre, is pivotal. The MD auditions the cast, oversees their rehearsal and is responsible for overall maintenance of the musical side of performances. This is also true in many churches. Sadly, it is not universal. Too often in churches this aspect of a service is left to a well meaning, but sometimes sadly lacking, individual.

In many churches it is the corporate singing of the congregation that carries the load. Even so, the role of the oversight of music should not be considered marginal. Even the most skilled practitioner can be cut asunder by the choice of songs or musical style. One can pontificate at length on the kind of music one likes but ultimately the warnings are clear: whatever is done should be done well. Hymns should suit the theme of readings, preaching and the style of service; this is something to be learned from the theatre. I recall one service of celebration which was full of mordant chants. Likewise a service of reflection and repentance was peppered with the worst sorts of happy–clappy material.

In 1999 the Guild of Church Musicians issued an excellent study guide, *Seriously Silly Hymns*. Written by English tutor Anne Kennedy and the church musician E. (Ernie) H. Warrell, it pointed to many of the pitfalls of mismatching lyrics to music. It did this in a considered article and then, even more powerfully, by providing examples of the kinds of train wrecks that can occur: sombre lyrics to happy tunes; too many notes on short syllables or too many syllables with insufficient notes; using well known words to inventively bad musical accompaniment; putting words to well known tunes. Once again, it proves the educative potency of laughter.

The Mystery Worshipper also mentions preaching. For those in the evangelical tradition, preaching holds an exalted position. Much time is given over to the preparation and delivery of sermons. I know of one London church which expects a forthcoming preacher to carry out no other duties beyond the research, preparation and writing of a sermon, which can last up to an hour on delivery, in the week preceding their mounting the (in their case metaphorical) pulpit.

I have likewise asked several clergy when they last heard or saw themselves carrying out this part of their ministry. The responses are alarmingly similar: unless they serve a church which either records them visually or orally for broadcast, usually on the web, they have not been subjected to this kind of monitoring since they were in college. The time lag, of course, depends on how long they have been in public ministry.

Without some structured reviewing bad habits can become entrenched. Likewise, good practice goes unmonitored and

unrewarded. Some churches have a sermon discussion group. In my experience, these tend to concentrate on the text that has been delivered. While it is important to look at content, the text needs to be considered in context of presentation. Speaking personally again, I have heard some fine sermons ruined by dire presentation – mumbled reading into the stand that holds the typescript; unfortunate public address systems cranked up too loud or too soft; personal gestures such as ear cleaning, nose picking or repetitive nervous gestures such as collating pages, wiping the edge of a pulpit, brushing of facial hair or readjustment of the nose bridge of spectacles. All these things can be needlessly distracting. To correct such matters first requires awareness. Too often in church circles people resile from such criticism in the mistaken belief that it will discourage the preacher. Surely anyone who speaks in public wants to ensure his or her message is conveyed to the best effect?

By the same token, I have witnessed what appeared to be stunning sermons. On asking for a copy of the text, I have been surprised to reflect that what seemed to weighty and inspiring material turns out to be pretty thin stuff. Here again, criticism can assist the preacher in the same way as it does the theatre. A mediocre play can be lifted by the grandeur of the actors, the construct of direction, or even the design of set and costumes. Likewise a showy preacher can hide the flaws of substance. Pointing out the paucity of material should be constructive and educative; it can only help their ministry.

It would be good if appropriately trained monitors were employed by churches in much the same way as the theatre uses critics. The critic provides an outsider's view on what is being presented. At its best, their work can analyse, assess and encourage. They can likewise point to improvements or to areas that can be worked on for the general benefit of the church: both individual and the body corporate get something out of the process.

This is all an external path, a way of improving the inner preparation of those who are seen in public either in performance or in public liturgy. There is also the complementary inner path that can be trod. That is what actors often call the third eye. It is that inner aspect which will be the subject of the following chapter.

Chapter Fourteen

Developing The Third Eye – Inside Looking Out

The preceding chapter looked at external criticism and possible ways that it might be used to the benefit – and sometimes for the opposite effect – of a performance. There is an alternative to this. For a performer there is an arguable advantage in nurturing something of an inner critic, one that can offer comforting words in secret while not disturbing the outer action being presented. This is often referred to as a third eye, the equivalent of an extraneous monitor reporting back to the actor of what is going on around them.

Some would argue that this is less a critic than an independent viewer. I suggest that it is a mixture of both, as evidenced in the better practitioners of theatre and religious ceremonies, that comes to the fore. The third eye can provide corrective suggestions while taking an overview that the ego might not immediately resort to. It also involves elements of the external critic and internalises them for use at the time of presentation. It is a kind in service performance engineer, someone on the scene who can keep an overview while being involved in what is taking place.

It is possible, of course, to call on the expertise of a fellow practitioner. If they are taking part in the same performance, be it of a theatrical text or a liturgical action, it is not always possible to do this while it is underway. Their input, however constructive or corrective, can only be offered at the conclusion. By and large, they do not feel confident in intervening while a performance is live.

There are many stories, however, of this being carried out, sometimes with what almost passes as a gnostic code: the raised upstage eyebrow to let someone know that their fly is undone; the widened eye when a surprising stress is offered on a well known line; an innovative gesture to alert others to a danger on stage while not broadcasting such information to the audience.

Is this working?

In church this used to be the realm of the sotto voce confidences that could be made, especially when the officiating party had its back to the congregation. Much of this form of interchange has necessarily had to stop. Microphones, whether worn on the body or

highly sensitive units on stands in and around the altar, mean many formerly private comments are now broadcast. There are numerous illustrative warnings of clergy believing themselves to have reached the safe haven of a vestry at the end of a service giving air to some private frustration with the music, serving team, guest preacher or leading lay officer, only to find later that their unguarded comments are causing glee or gloom to unexpected auditors.

There is an additional pitfall in seeking the view of another performer. Not all actors are capable of seeing what is happening on stage in a rounded way. They have, quite simply, not got to the point where they have developed this third eye. Some of them, to both their credit and debit, are so caught up in the moment of their own performance that they cannot really assess what is happening around them. One would hope that this is what the rehearsal period is for: with colleagues under the rule or collaboration of a director – it can be either – the collective cast gets an overview to allow their personal input to be nourished and, it is hoped, to thrive.

This, of course, presupposes a sense of generosity on a performer's part. I have seen, indeed have been in the same rehearsal with, a manipulative actor who seems to suck the energy out of colleagues, carefully monitoring and drawing on their offerings, while giving nothing in return. This can be bamboozling and upsetting. An actor can come to feel the relationship on stage is one sided; there is no reciprocity in the rehearsal room. If a director allows such uneven efforts to continue, this can have potentially damaging effects on others and, ultimately, on the production itself.

I have witnessed, again as an observer and participant, the explosion of a fully–fledged performance revealed for the first time on opening night. The protagonist has effectively hoovered up the energy and creativity of others, sifted and processed it fully, but privately, to present a performance that has not been shared before. Other actors can seem diminished, overawed and, in some cases, wildly angry.

The unreliability of colleagues has another factor. While perhaps not intentionally – though that is impossible to rule out – some actors can only offer advice that in turn contributes to the betterment of their own appearance on stage. They may not be meaning to do down the efforts of others. It is more that they are

so passionately committed to what they are doing themselves that they cannot esteem the work of another.

Who am I?

Peter Barkworth, a great actor and teacher, wrote two wonderfully practical books for the performer. In the first, *About Acting*, he gave consideration to Criticism. I believe it holds true for performance in the wider sense in church or on stage. It embraces both the inner and outer paths of awareness.

> *Everyone has faults and it is good to have them pointed out occasionally by the director or by friends. If the fault is one which applies to your acting in general, as opposed to just your performance in the play, do take special heed and word as hard as you can to eradicate it.*
>
> *People may tell you that you fade out at the ends of sentences, that your speech is not clear enough, that you blink too much, that you fidget, that you smile too much, that you don't smile enough, that you don't listen properly, that you gesture too much, that you don't gesture enough, that you're content with too little, that you complicate things unnecessarily, that your hair–style doesn't suit you, that you've got a funny walk.*
>
> *Listen and work!*
>
> *But don't listen to everybody. Rely on the director and close friends. If you listen to everybody you will get awfully confused, for you will hear so many different things. If you are very, very good everybody will say so and have similar reasons for thinking so. If you are very, very bad everybody will say so, behind your back, and have similar reasons for thinking so. But if you are somewhere in between very, very good and very, very bad, which is where most of us are most of the time, everybody will know that all is not perfect, but will have differing reasons for thinking so.*
>
> *It's as well to remember, always, that you can't please everybody.*[14]

For all these reasons many actors use what they call the third eye and it is a skill that many in the church could draw on. It is a skill that draws on what you see in others and, applying those lessons in as an objective way as possible, seek to apply them for the benefit of the presentation of either show or liturgy. It also

means that action can be taken at the time of something occurring, which is the natural order of things, instead of waiting for notes or feedback later.

There are some important and easy questions to ask:

- am I standing in the right place for what I am doing?
- can I be seen?
- can I be heard?
- am I standing in a position which is altering the shape of the scene?
- am I preventing someone else from being seen?
- am I stopping another person from being heard?
- is there something assisting me in doing what is best at this time?
- is there something conspiring to compromise my best efforts?

These questions can seem like a performative chapter of faults but, if carried out in the correct spirit, can allow some corrective actions that enhance an event. To that end, a mild and gentle move, rather than a rebuke to others or oneself, allows the whole service or performance to improve. For example, it is worrying to watch a professional actor unable to stand on the right part of the stage to gain the best effect of lighting. To that end, actors should learn to "feel their light". How people do this depends on their third eye: how they monitor what they do.

Standing back

Some people have an innate sense of what feels right. They carry with them a monitoring intuition which allows them to gauge where they should be in a scene. If someone strays from their allocated place there are two ways to correct the problem: one is to insist that the other move to the correct place; the second is to make a yielding adjustment which allows the tableau to be formed and saving the rebuke for later. Once again, the McGeary rule can be used here: symmetry over pedantry.

This speaks of an important quality we can bring to performances in the widest sense. If we are worked up about what we are doing and all that seems apparent is our tension, we are not acting to our best lights. I watched one priest preside at a service in a church that had been configured in a way that approached his dream layout. Despite all this he stood in such a

ball of tension, rising and falling on the balls of his feet, nodding each time he spoke with emphasis that the fluid grandeur of the setting was lost. He was riveting, but for all the wrong reasons. And his behaviour was distracting in the extreme. A would be triumph was transmogrified into travesty because he was so nervous.

Telling someone to relax when they are tense is often counterproductive. Doctors, sports instructors, theatre directors and liturgists all offer the same advice – "Just relax". Finding a way to do this is not as easy as offering the advice. To that end, the third eye can help. You can monitor your own tension and, if you have worked on this before – the best solutions often draw on practised techniques, be they deep breaths, exercises of imagination, muscle awareness – simply draw on your store of experience. A keen sense of self-awareness will detect the early warning signs and, if all goes well, will avoid the worst manifestations of public discomfort.

The same goes with personal grooming. It is only in the upper echelons of the theatre that one has a personal dresser, if an actor has a dresser at all. Most of the responsibility for appearance, from makeup to putting on a costume, is the actor's. Likewise the hand prop will be part of the actor's preparation. This needs concentration and a good memory. I recall with embarrassment and shame turning up on stage as Oliver in the Act Four of *As You Like It* without the bloody handkerchief that was to presage the fainting of Rosalind who, at that point, was still parading as the boy Ganymede. (It was one of two plays in different parts of the world where I was called on to double parts and, in both, had to pass myself coming on stage in one character as I left it in the guise of another. I found it bewildering on both occasions.)

Forgetfulness is both forgivable but worrying. As a student I watched spellbound as the actor playing Juliet, having been told by the recumbent and supposedly dead Romeo that he had forgotten to bring on the dagger she would need to end her days on earth, inventively bashed her brains out on the slab where he lay. It was chilling watching this beautiful young woman trying to make up for someone's oversight. It also broke one of the cardinal rules of theatre: no matter what is being portrayed on stage, the audience should not fear for the personal safety of the performer.

A veneer of protection should ensure that even someone whose character is being murdered, or who is having their eyes plucked out on stage, is safe beneath the enacted horror.

An experienced actor or president at the liturgy will see some of the pitfalls before they come. They can draw on a well of assurance that can have an effect of those around them. I recall the panic in the sanctuary at a solemn celebration of Holy Communion which involved bells, incense and much ceremonial only for it to be cut asunder by the realisation that there were no wafers in the ciborium. Subsequent celebrations at the church definitely involved the metaphorical belt, braces and anything else that might keep the liturgical trousers up.

There is some easy advice to offer that cannot be that easy to accept in difficult circumstances: don't panic. There is a hierarchy of pitfalls and problems. The third eye will tell you which one is worth worrying about. For those in church, it is regrettable but no big deal that the lavabo towel has not been placed on the credence table. A purificator can be discreetly used for this purpose. Likewise if there is no water in the lavabo jug, there is nothing to stop the president from washing hands in water from the cruet. If there is a bigger problem, it is often wiser to stop and seek assistance. That avoids an accumulation of difficulties later on.

Sometimes it is better just to acknowledge something has gone wrong, pause, go back to where matters can proceed without being compromised and resume the action. There is nothing worse than trying to ignore a dropped letter, hankie or prop if they are not supposed to be on the floor. There being there can raise a false expectation in an audience. Better to acknowledge the mistake, correct it and move on. Peter Barkworth makes a similar point about Mistakes in *About Acting*. He writes:

> I like the old actor's adage: if you make a mistake, acknowledge it.
> It is no use pretending it hasn't happened.
> If you trip over a rug, acknowledge it. Look at the rug. Straighten it.
> If ash drops on a carpet, acknowledge it and do something about it.
> If you drop a glass and it breaks, pick up the pieces. If your cigarette goes out, re–light it. [15]

This is using the third eye to its proper effect. It takes on board the simple reality that those who not involved in the acting out of the service or performance can see something has gone awry. Those on stage might choose to ignore the extraneous matter. Those sitting watching will not. The third eye allows you to move to the other side of the action, to see how it is seen and thereby ease the discomfort that may be involved.

A third eye should also involve a little forgiving indulgence. As Peter Barkworth wrote, you cannot please everybody. It is pointless to try to do so. If errors are being made and they can be gently corrected, use the gentleness. There are plenty of people who will supply the brickbats for you. Actors, in my experience, can be crushing on themselves. There is a story of actor who fluffed a line in a complex script by Tom Stoppard. The author was reportedly delighted by the performance but, when he went round to congratulate him on it, found the actor almost inconsolable in the dressing room. All the positives had evaporated in his fixation on the fleeting error. As my wife, Adey Grummet, says when something minor goes wrong on stage, "Nobody is bleeding and nobody died. After all, it is not a cure for cancer."

I have been called on several times to assist in the training of deacons as they prepare to preside at the Eucharist for the first time. After I had done this a number of times I noticed, to my regret, that the soon-to-be priests appeared overawed by the responsibility. I heard one saying as they left a session, "There is almost too much to think of." As I prepared for this teaching the following year, I asked a number of experienced priests what single piece of advice they wish they had been offered when they were in a similar stage of their ministries to those who would be at the training session. The most singly consistent comment was one of encouragement: "Tell them that whatever they do, they cannot really do it wrong."

This is not a charter for laxity. What it offers is the equivalent of the director's advice: "You've done the work. You know the journey of the play. You know its arc, its ups and downs. Just go out there and enjoy it." The advice for the new priest is similar. "Do it for God. Do it to the best of your ability. And with continued acquaintance with the tasks, your performance can improve."

As one gains more experience there is the concomitant growth in confidence. As I have noted in other chapters, this can lead to

a false sense of security, almost an arrogance, in assuming that one's skills are better than they are. On the other hand, one can cripple oneself with relentless carping and hectoring. The third eye should allow you to draw on your critical faculties but do so in a manner that builds up the effectiveness you have in what you do. In doing that, the effectiveness of a performance improves not just for the practitioner, but also for those who assist in being part of the wider circle.

Chapter Fifteen

Zen, Kabuki And The Mass

Japan is a bustling and, some might say, an aggressively modern nation. Yet its history is long and rich. The vibrant veneer has been placed over, and in some places replaced, a deep and complex history. People and institutions in the West can and do learn from this heritage. Indeed, people from all over the world go there to tap into it.

Japan has given rise to a plethora of skills and disciplines. The more recognisable are relatively modern exports: sushi, manga, cartoons and karaoke. They are, however, relative newcomers. Martial arts, food, architecture, complementary health, the arrangements of flowers, paper and objects, as well as tea, presented with ceremony, are among the array of traditional arts that attract the devotee. The recognition of masters in any field makes for a productive encounter.

There is also much to be learned and morphed into applied activities for those from non-Japanese backgrounds. Nowhere is this more apparent in its traditional religious and theatrical practices. These, again, are diverse and take study and application to learn and sustain. I want to look at two of the more readily recognisable aspects of Japanese life: Zen and the theatre. Each can have a profound impact on those who seek to improve their performance in church ritual.

To use the word Zen is to court derision. It has become something of a clichéd touchstone to some. If a place or process has an element of mystery coupled with stillness, some draw on "Zen" as an adjective. I have seen plays in which there is little plot, books in which there is negligible substance, meals of minute proportions all described by lifestyle journalists as being "a bit Zen". For many this is merely a code-phrase for something foreign, eastern or Japanese or, more worryingly sparse or in minute proportion.

Zen is in many ways one of the most embraceable and disconcertingly elusive practices of Buddhism. It has its rarefied and esoteric aspects, such as Shingon, but it offers a universality that many forms of the Enlightened path cannot. A layperson is an

equal to a monk in Zen. It does this by stressing two things: that nirvana comes through meditation and that truth is apprehended by releasing ourselves from ordinary language. For this reason it is often frustrating to read about. The desire to capture, codify and catechise is one aspect Zen counters.

This elusiveness stems from Zen being essentially practical. Again words cannot do this justice. To do it is to understand it. To wrestle with it is to do it. To confront it is to do it. To evade it is to do it. No amount of explanation, theorising, apologetics or instruction can throw light on it. Enlightenment comes to the practitioner who, once having attained it, must let it go.

Christianity can learn and has learned much from this. On one level this can be seen in those who have gone to Japan to draw on these riches. The writings of Thomas Merton have provided insight and spiritual comfort to many. His was a work of synthesis, of learning from Buddhism and letting it flourish in Christianity. William Johnston has done similar work while often providing intellectual and theoretical frameworks that bridge the two religions. He has also noted some of the criticism from some Buddhists. They are concerned that a naivety from Christians can distort the Buddhist way.

East meets west

Some Westerners have mastered the processes of Zen and offered them to others. Two names serve as examples. The Jesuit priest Hugo Enomiya–Lassalle and Elaine MacIness, a nun of the order of Our Lady's Missionaries, attained the status of *roshi*, a master in Zen meditation. The respective titles from one book by each can give a steer to what Enomiya–Lassalle and MacInnes offer – *Living in the New Consciousness* and *Light Sitting in Light*. The books, however, cannot provide the path. They merely point to steps toward it. It is experiential and the way to come to terms with Zen is to sit, either alone or in *sesshin*, the communal meditation.

The underlying principle is the same between Zen and the practice of prayer for a Christian. How does one learn to pray? By praying. Is there a way to learn more about prayer? Yes, by praying. What does one do if one experiences barrenness in prayer? Pray. How can one deepen a sense of the divine? By prayer.

This parallel of practice deepening the experience is applicable to liturgy. Having expressed concern that the term Zen is belittled by some who use it, I realise that what follows may be construed as committing the same error.

Christian liturgy, especially the mass, can be approached in two broad ways. They can be characterised as left–brain or right–brain. The left–brain path requires explanations and reasons. Before setting out of the worship quest, the classic left–brain thinker will want to know what happens when and the reasons for it. Information precedes practice. To take but three of a wide range of enquiries, why does the congregation:

• stand for the opening hymn?
• turn to face the gospel?
• kneel or genuflect?

Similar questions are posed about the role of the priest. Why does a priest:

• robe?
• make specific manual acts?
• sit in a certain chair?

There is puzzlement over particular worshipping habits, such as the use of incense, why one congregation stands when another would kneel, why people may close their eyes, raise their hands, prostrate themselves or kiss icons.

The left–brain demands a reason, an explanation for these practices. Their enquiries may go deeper. These can reveal another aspect of the left–brain Christian. What is the scriptural authority for such activities? When were they implemented? What was the historical process that allowed them to gain approval or gain precedence over other actions? How and why have they changed? All this can inform and entertain. But it may not actually make the *practice* of religion any more engaging.

The right brain provides an alternative. It can answer through experience. How do you understand the mass? By assisting at it. How do you grow in reverence for the mystical complexities of the Eucharist? By taking part in them. How do you meet God in the actions of the liturgy? By doing them.

Here the parallels of Zen and religious practice meet. Practising one's religion has become something of a dated term. There is a consistent challenge from many encapsulated in questions such as:

- why do I have to join others for worship when I can encounter God on my own?
- what can people with whom I have so little else in common teach me about faith?
- how can this make any sense in my daily life?

The right brain can provide the tantalising and annoying answer that these questions are secondary. Not all can be explained. Some understanding is achieved in ways other than the rational. Experience is a legitimate way of coming to terms with broader questions. This could be characterised as a form of Zen.

Again, I hesitate to make what might be considered a crude distinction. Within Christianity there is a tension between left-brain and right brain churchmanship. Broadly speaking, Protestantism is a left-brain activity: the study of the book, the clear and sometimes harsh definitions of acceptable doctrine, the insistence on word before experience. Catholicism or Orthodoxy, while not without their own left-brain elements, provide a right-brain experience, at least in their worshipping life. Yet the practice of religion, especially by assisting at the Eucharist (what used to be referred to as hearing the mass), can provide a way forward. One can grow in faith, learn and understand more by doing, by yielding to what are known of the mysteries and letting them move within you.

Lessons from Kabuki

Japanese theatre has a long and varied history. Perhaps the most recognisable of the ancient arts is Kabuki, which has its historical roots in the sixteenth century. These draw on Kabuki's more ancient cousins, Noh Theatre and Banraku puppetry. These, too, are believed are to have had religious sources. Here is a common source for theatre in both east and west. As the actor took over what were originally tasks for the priests in Ancient Greece, the theatre moved to a wider stage, both literal and metaphorical. Kabuki theatre, like all of Japanese life, was affected greatly by the Meiji restoration and contact with the west. Yet it has been able to remain a quintessentially Japanese experience. And, unlike many of the more ancient arts, it still has a widespread popularity. To indicate its primacy, all one needs to do is look at the comparative number of performances of Noh and Kabuki plays. In Tokyo there

is a performance of a Noh play about once a month at the National Theatre. At the Kabukiza in the Ginza district of the same city, there are two programmes, the first starting at eleven in the morning, each day.

It is possible to be daunted by Kabuki theatre. After all, it comes from a uniquely Japanese history and cultural background. To assist the foreigner, the Kabukiza provides rentable headsets which explain plotlines and subtleties that might be lost on non-Japanese members of the audience. In a comforting peculiarity, similar headsets are available for Japanese patrons.

In one of the introductory English commentaries, the listener is asked to consider differences between western and Kabuki theatre. The former is representational. The latter is presentational. One is concerned with ideas while the other is concerned with form. One purports to portray reality and the audience pretends that this is so. Kabuki does not rest on such a mutually suspended reality. There is no illusion that what is being on stage is lifelike. The audience, for its part, recognises this and is given permission to make carefully codified responses to acknowledge what is happening on stage.

The commentator makes much of the role of the actor. People in the audience are not there for the surprise of plot but to see how the actor does his work. All actors in Kabuki are male. To assist patrons in their selection of pieces to attend, the management publishes lists which actors, some of whom attain the title of National Living Treasures, will play what roles at given performances. These lists are published and are keenly perused by theatre lovers.

The audience usually knows the story or the play. People may have seen the same play several times, perhaps comparing the performance of one of the actors with another. It is this element of Kabuki theatre that can be instructive in considering liturgy and the performance of those who conduct it, especially the work of the priest. As I have said before, no consideration of this can exclude the work of the congregation assisting at the Eucharist.

The format of the Eucharist is set. Its five elements – gathering, listening, remembering and giving thanks, sharing, going out – have minimal variations. These can be relatively easy to pick: listening has the greatest variation with different texts to be read

and pondered through the homily while remembering and giving thanks can draw on a range of sources for the formal Eucharistic prayer. The Kabukiza commentator's observation, though, holds true for those who attend mass regularly. They do not go to be surprised. They know the format and probably expect it to follow the familiar pattern. What is being enacted is something they have assisted at before. Because the significance of the sacred performance does not reside in novelty, the participants can be exposed to the complex subtleties of the mass.

It may be worth a brief comparison of the mass to other forms of Christian worship that do not take the traditional mould. Some churches seek to present, even relish in, services (or meetings) that have a unique form. Their leaders can claim to have no liturgy. Gill Behenna, a priest with great experience of working with Deaf people, says this is not true. Liturgy, she argues, is inevitable. Her wide-ranging definition is enticing. Behenna says wherever people gather, do something and disperse, they are performing a liturgy. What happens within this is a certain surprise element. The music and songs, readings and usually long sermons, combine to form the act of worship. What people seem to want is freshness.

This could be construed as criticism of more formal services. Indeed, some church leaders are adamant that traditional worship is not interesting to the modern mind. Lessons are available from Japanese theatre. The purpose of the religious gathering is not necessarily the telling of story of salvation. Worshippers can be drawn into the complex web of narrative and formality that is the mass. In this way a profound encounter with God is possible.

The Kabuki actor has to be extremely concentrated. He is expected to be able to act, dance and sing. These are the very elements of Kabuki: *ka* meaning song, *bu* dance and *ki* an historical development from the word *su* meaning to do. The role of the priest in the sacred drama of the liturgy likewise draws on these three elements. A priest performs a specific part in the song and dance of the gathered Christian worshippers do in memory of Jesus. To that end a priest should be well versed in the skills of liturgy.

A vital element of a Kabuki actor's work is stillness. Elaborately dressed, the actor is often called on to hold on to formal or submissive attitude positions for what can seem a long time. This requires skill and discipline. One cannot remain kneeling on a

wooden stage for long periods without practice. The seemingly static nature of some of Kabuki is actually the epitome of the actor's skill.

A priest should likewise develop what could be deemed a professional stillness. This can be expressed in spiritual terms such as drawing on the centre that is God. It can also be cast in more negative terms: the presidents who cannot leave themselves or what they are wearing alone. Or there is the vicar who believes that contact with the gathered community is the aim of worship. Hence, we are treated to the inanely smiling priest, the ingratiating commentator on actions about to be undertaken, as well as the provider of page numbers at any given point of the action. Appropriate stillness allows space for others in church to gather their thoughts. The to-many redundant view of custody of the eyes can apply to other faculties. Fidgeting, especially from someone who is in a prominent place, detracts from the overall aim of directing people beyond themselves to an encounter with the Godhead in Christ. That is where the text of the mass is leading. It is the priest's duty to point the way on this journey.

Kabuki actors have a particular way of speaking. It is affected yet it is fit for purpose. The delivery of lines in a mannered way is part of the performance. No matter the cultural nuance, the actor can be heard. I hope the days of the much-derided parsonical voice are over. Although I have experienced some extraordinary utterances in church. Unfortunately, they have mainly been in cathedrals. So much gets off to a bad start when the clergy taking Evensong commences with "O Lewaaard, awhpin thou ahh leeps". It is downhill from then on. Spoken language can likewise escape them. I am reminded of a query to a choral director in America's south about a "diyapthong". I have squirmed in the stalls as one cleric bungee-jumped his way along vowels.

The career of a Kabuki actor is a long one. If good health subsists, there is no impediment to performing well in to one's seventies. This is particularly intriguing when an actor is a specialist in *onnagata* roles, i.e. men who perform women's roles. I have a fond memory of a friend of mine coming out of Sadler's Wells Theatre in London after we had seen a performance of a Kabuki play. He turned heads when he stopped and exclaimed, "I have just seen the most beautiful young woman I have ever seen, and she's a 73-

year-old man!" Actors are trained in types of roles, each of which has its own makeup as well as vocal and physical mannerisms.

A priest's calling is considered lifelong. Much can be made of the verse from the Psalms,

The Lord has sworn and will not change his mind,
You are a priest forever according to the order of Melchizedek.
(Psalm 11. 4)

Some take a personal authority from these words. This, like marriage, can be for better or worse. Others are humbled by them. It is enough to remember that a priest is ordained, therefore the priest's life is put to use on behalf of the church for others. The actions of priests are, or should be, therefore directed beyond themselves. This is especially so when performing in the sacred drama of Eucharistic liturgies.

A Kabuki actor, or indeed many of his counterparts in the west, will not be seen on the street in costume or in makeup. Such externals are intended for performance. On the stage they contribute to the entertainment. Robes are also intended for special use. They should be used for the purpose of celebration and removed before meeting people after services. This view is, sadly, is not necessarily applied by all clergy. This is a shame as, once again, it confuses the message. "Go in peace to love and serve the Lord" or "Go now, the mass is ended" should be an aural signal that the gathering of worshippers has finished. The audience leaves the theatre to reflect on the show. The actor goes to the dressing room to remove costume and make up. Having done so, social encounters are possible. A priest in a chasuble or other robes shaking hands of parishioners at the door, or even drinking coffee, might be carrying part of the Ministry of Politeness, but does not serve the liturgy. There is much that can be learned from elsewhere, such as the theatre and its particular manifestation of Kabuki in Japan.

References And Credits

1 "Nicholas Craig", *I, An Actor*, Pavilion Books, London, 1988.

2. The V-effect, *Verfremdungseffekt*, is usually rendered into English as the Alienation or A-effect. It suggests that by "making strange" the events which appear on stage, the audience will be led to a more intellectual encounter with the issues behind the scenes being portrayed.

3. The Collect for Purity from *Common Worship* of the Church of England, © The Archbishops' Council, 2000. Used by permission.

4. This is the Jerusalem Bible translation as quoted in *A Pocket Ritual*, Mayhew McCrimmon, Great Wakering, 1977.

5. The opening dialogue is from *Common Worship* of the Church of England, is copyrighted to The Archbishops' Council, 2000.

6. From Eucharistic Prayer B, *Common Worship* of the Church of England, © The Archbishops' Council, 2000. Used by permission.

7. The prayer over the water from Baptism Service is taken from *Initiation Services* published by CBF. © Archbishops' Council. Used by permission.

8. ibid

9. Phyllis Hartnoll (ed),*The Oxford Companion to the Theatre*, Oxford University Press, Oxford, 1975, p 219

10. James Roose-Evans, *Directing a Play*, Studio Vista, London, 1968, p 92 Used by permission of the author.

11. Hamlet, Act Three, Scene Two

12. ibid

13. Caroline Cornish, *Can You Hear Me At The Back?*, Bi-Vocal Press, Exeter, 1995, p 22

14. Peter Barkworth, *About Acting*, Secker &Warburg, London, 1984, p 104

15. ibid, p 155

Lightning Source UK Ltd.
Milton Keynes UK

176985UK00002B/145/P

9 781905 565191